LEGENDARY L

OF

NEWTOWN
CONNECTICUT

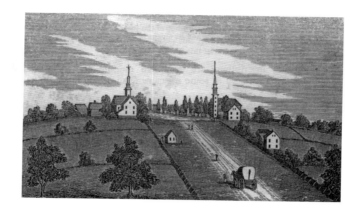

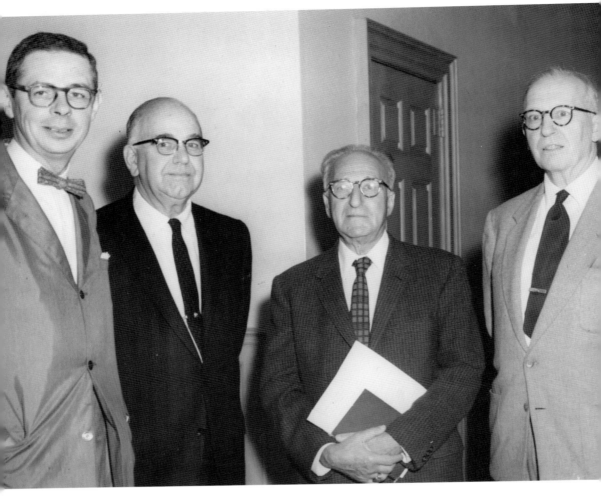

Newtown Historical Society

In reaction to the threatened destruction of a Main Street landmark house, a group of leading men in Newtown gathered to form the Newtown Historical Society, dedicated to preserving the town's past and protecting its heritage. The four men who headed this effort, seen here in 1963, are, from left to right, Tom Cheney, a local attorney; Paul Smith, editor and publisher of *The Newtown Bee*; Louis Untermeyer, a nationally known poet and anthologizer; and Frank Johnson, grandson of Newtown's first historian, Ezra Johnson. (Courtesy of the Newtown Historical Society's Historical Images Archive.)

Page 1: Newtown Village, 1836

This woodblock print, by John Warner Barber, is the earliest depiction of the center of Newtown. It clearly shows the Congregational meetinghouse (right) and Trinity Episcopal Church facing each other across the intersection, in the middle of which the first flagpole would be erected 50 years later in celebration of the nation's centennial. The buildings had been in this configuration since 1792 and would be so until the new Trinity Church was built slightly to the south in 1870. The image also shows the exceptionally wide Main Street (132 feet) and the Middle District schoolhouse in the road's right-of-way, a common placement for schoolhouses in the 19th century. (Courtesy of the Newtown Historical Society's Historical Images Archive.)

LEGENDARY LOCALS
OF

NEWTOWN
CONNECTICUT

DANIEL CRUSON

LEGENDARY
LOCALS

Copyright © 2013 by Daniel Cruson
ISBN 978-1-4671-0071-7

Legendary Locals is an imprint of Arcadia Publishing
Charleston, South Carolina

Printed in the United States of America

Library of Congress Control Number: 2012954911

For all general information, please contact Arcadia Publishing:
Telephone 843-853-2070
Fax 843-853-0044
E-mail sales@arcadiapublishing.com
For customer service and orders:
Toll-Free 1-888-313-2665

Visit us on the Internet at www.arcadiapublishing.com

On the Cover: From left to right:
(TOP ROW) William Johnson, highway supervisor (Courtesy of the Historical Image Archive, page 16); Betty Downs, librarian (Courtesy of the Cyrenius H. Booth Library, page 38); Marcus Hawley, businessman (Courtesy of the Historical Image Archive, page 18); Thomas Jefferson Briscoe, stage driver (Author's collection, page 108); Virginia Lathrop, dancer (Courtesy of Diane Wardenburg, page 62).
(MIDDLE ROW) Annie Murphy, teacher (Courtesy of the Historical Image Archive, page 36); William Edmond, judge (Courtesy of the Historical Image Archive, page 12); Otis Olney Wright, minister (Courtesy of the Historical Image Archive, page 53); Arthur Spector, athlete (Courtesy of The Newtown Bee, page 102); Mary Hawley, philanthropist (Author's collection, page 17).
(BOTTOM ROW) David Merrill, artist (Courtesy of Tom Kabelka, Republican American, page 64); Mae Schmidle, legislator (Courtesy of The Newtown Bee, page 20); Florence Johns, actor (Courtesy of the Historical Image Archive, page 59); Eleanor Mayer, farmer and businesswoman (Courtesy of The Newtown Bee, page 32); Arthur "Doc" Crowe, storekeeper (Courtesy of The Newtown Bee, page 87).

CONTENTS

ACKNOWLEDGMENTS

Any work of this magnitude is obviously the product of many people. This is especially true of a book that includes many photographs. It literally could not have been produced without access to the photograph files of *The Newtown Bee.* I wish to profoundly thank Curtiss Clark, the editor, who was always willing to spend time helping me find the proper image for one of my subjects.

I wish to thank those friends with whom I shared some of the stories on which I was working. I am thankful for their patience, apparent lack of boredom, and valuable suggestions. I am especially grateful for the assistance of Andrea Zimmermann, who was always willing to help me search the Internet for obscure information and who has been so generous with her own photographic sources and with very good advice. I also thank her for the countless walks around the "Block," during which she listened as I rambled on about exceptional people in town.

I also thank Erin Vosgien of Arcadia, who has served as my editor during the writing process. For her cheerful willingness to advise me, especially after the trying days of December 14, I will always be grateful.

Unless otherwise noted, the photographic material for this work has come from the Newtown Historical Society's Historical Images Archive (HIA). A good deal of the historical information contained herein was gleaned from previous works from the author, Andrea Zimmerman, and Mary Maki. These works are cited in the bibliography on page 125. Neither Andrea nor Mary is to blame for the mistakes I have made in using this material.

INTRODUCTION

Newtown is distinct from the rest of the towns in Fairfield in many respects, each of which is due to the legendary locals who lived here and made unique contributions to the town. Some of these men and woman made primary contributions, such as the town benefactress, Mary Hawley, who between 1920 and 1930 was responsible for the creation of four major public buildings that molded the character of 20th-century Newtown. Earlier in the town's history, William Edmond served in the House of Representatives in Washington, DC, where he made an impact on the developing nation. But he was also a local Revolutionary War hero who consistently returned to Newtown, leaving an indelible imprint on the town. The town hall is fittingly named for him. Many others loom less large but are important in having shaped different facets of Newtown government and culture.

Like many other towns in the inland areas of Fairfield County, Newtown began as primarily reliant on subsistence agriculture. Most of its farmers were common men who have left little behind but their name, but some were very influential. Ezra Johnson had a profound impact on the educational structure of the town and distinguished himself as Newtown's first historian. Another notable agriculturalist was Theron Platt, whose experiments in potato breeding had international ramifications and whose son, Philo, became the head of the Connecticut Department of Agriculture. More recently, Shirley Ferris, along with her husband, Charles, have continued the Ferris family farm. She was the second Newtown citizen to head the state's agriculture department.

Countless teachers have left individual impacts on the town, but some, such as Prof. Charles Platt, had an enduring effect on Newton's musical culture. In a more abstract way, the Smith family has seen to the education of the town in contemporary affairs through the publication of the weekly newspaper, The Newtown Bee. Its editorial dynasty spans Newtown's history from 1880 to the present, supplying information on current affairs and preserving that information. The newspaper's archives have become a primary source for Newtown's historians.

Newtown has also had many healers. Some, like Cyrenius H. Booth, achieved immortality though the benefactions of his granddaughter, Mary Hawley. Others achieved a quiet immortality by healing those who would distinguish themselves in other endeavors, in Newtown and beyond its borders. Their contributions have made them silent legendary locals.

The visual arts, literature, and music have benefited from men and women who settled in Newtown because of its proximity to New York City. Their contributions were national, but these artists frequently made incomparable contributions to the town. Virginia Lathrop, for example, came to Newtown in the early 1950s with her husband and dancing partner, Mack, after a very successful career in vaudeville. She established the Lathrop School of Dance, which catered to Newtown and the surrounding area. It has just celebrated its 60th year. The Stardust Review has become an anticipated annual event, continuing even after Virginia Lathrop's death in 2009. Similarly, Wilton Lackaye with his wife, Florence Johns, retired from the New York stage to the center of Sandy Hook. He became a founding father and avid supporter of the Sandy Hook Athletic Club (SAC), which developed athletic facilities that served to shape the bodies and minds of Newtown youth for several decades.

Business in Newtown has always been important, whether the local general store supplying groceries and other merchandise that farmers could not produce themselves, or factories, such as Fabric Fire Hose or Curtis Packaging, that supplied jobs. Entrepreneurs—such as James Brunot, who developed Scrabble into an internationally popular game while living here, or William Upham, who invented the tea bag in Hawleyville—not only made contributions to national culture, but they also contributed heavily to the town as well, serving in local government and stimulating the formation of fire companies and other elements of local infrastructure.

Newtown has had its share of sports heroes, such as Arthur Spector, who played with the Boston Celtics. After his playing days, Spector guided the commercial and residential development of post–World War II Newtown. On a more parochial level, Harold DeGroat and Ann Anderson shaped physical education and team sports here. DeGroat was nationally known for his advocacy of physical fitness.

And then there are the local characters whose eccentricities have captured the affection of the town's residents. Al Penovi's plumbing supply barn on Washington Avenue was overflowing, literally, with bathroom fixtures. Though criticized by newcomers, Penovi could be relied upon to have the critical part to an outmoded porcelain toilet or a sink. Birdsey Parsons, who walked through Sandy Hook with his donkey, Betsey, became a local landmark. Inventor Robert Fulton, who developed a car that could fly and a device for picking up downed flyers, made a trip around the world on a motorcycle and lived to write about it.

Running through all of these personal biographies is a men's club with the ponderous name "The Men's Literary and Social Club of Newtown Street." Consisting of many of the movers and shakers of Newtown, it championed causes as varied as the celebration of the town's bicentennial in 1905 and the replacement and preservation of the famous "Flag Pole in the middle of the road." The club advocated long-distance freight rates for local farmers. It was also known for developing educational and entertaining programs, especially for adults. Its members have been deeply involved in town affairs. The Men's Literary and Social Club still exists and is as committed to Newtown as always, although its activities have been more confined of late, to socializing, good food and wine, and pleasant political discourse. Members of the club, as well as nonmember legendary locals, have formed Newtown's present culture and provided continuity into the future.

CHAPTER ONE

The Creators of Newtown

A town is the product of the men and women who have lived there, especially the first settlers. They were responsible for creating the government and the economic nature of the town, and some become the stuff of local legends and folklore. It is equally true of those persons in subsequent years who were responsible for the modifications necessary to allow the town to adapt to changing conditions. There are also men and women who are not yet part of that heritage but are destined to become so.

Judge William Edmond, Rev. John Beach, Rev. David Judson, and Abijah Merritt are members of the pioneering group who established Newtown's legal and religious nature. Such men also established family lines, such as the Merritt family, which dominated the town until the last half-century. William Johnson and Arthur Nettleton are examples of men who helped see the town into the 20th century.

A giant among the creators of the town was Mary Hawley. She, guided by Arthur Nettleton, changed the nature of Newtown's education, culture, and government with her benefactions. Today, more than 80 years after her death, her gifts continue to serve the local population. The library, for example, has been the foundation upon which Newtown's education and culture has grown. With the changes and additions to the library that followed the first building, it has become the envy of Western Connecticut. This could not have been possible without Hawley's initial gift.

No less important are the modern leaders of the town, such as Mae Schmidle, whose extensive involvement has touched almost every aspect of its culture. Her time in Hartford as Newtown's representative to the general assembly has affected both the town and state beyond her signal piece of legislation, which saved the Flagpole in its original position in the middle of Main Street. She has reached legendary status in her lifetime and will soon be considered one of the modern creators of Newtown.

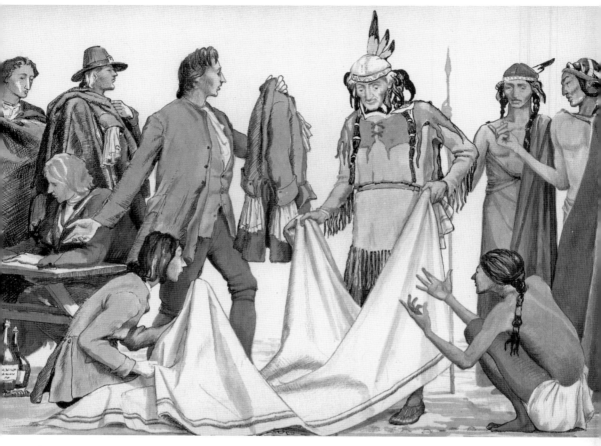

Purchase of Newtown, 1705
Although we do not know what the participants looked like, this rendering by John Angel (see page 58) of the purchase of land that would become Newtown captures the feeling of the moment. Shown standing are, from left to right, William Junos, Capt. Samuel Hawley Jr., and Justus Brush on July 25, 1705, when they negotiated for the purchase of a parcel of land from area Indians. Standing on the right side are, from right to left, the Pootatuck sachems Maquash, Masumpas, and Nunnawauk. The purchase price was four guns, four broadcloth coats, four blankets, four ruffelly coats, four collars, ten shirts, ten pairs of stockings, forty pounds of lead, ten pounds of powder, and forty knives. The parcel of land was approximately eight miles long and six miles wide. Unfortunately for the settlers, they had neglected to request authority from the Connecticut General Assembly to make the purchase and were forced to sell the land in 1708 to a group of men who would become the proprietors of Newtown. Ironically, Captain Hawley became one of those proprietors, and his descendants still live here. The other two purchasers were lost to history.

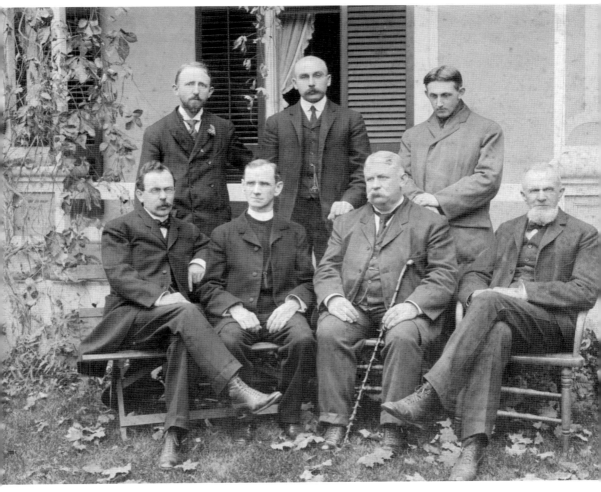

Newtown's Bicentennial, 1905

For the bicentennial of the land purchase, these local businessmen and ministers gathered to put together a celebration to commemorate the event. They decided that the true birth of Newtown was its purchase date, rather than 1711, when the town was formally incorporated by the general assembly. This decision would also guide the celebration date of the tercentennial in 2005.

The men gathered here were members of the Men's Literary and Social Club of Newtown Street, more concisely known as the Men's Club. The club's membership consisted of the leading men in town, so the job of formulating a celebration of the bicentennial logically fell to them. Shown here are, from left to right, the following: (first row) Rev. Otis W. Barker, minister of the Newtown Congregational Church; Rev. James H. George, minister of Trinity Episcopal Church; Michael J. Houlihan, town clerk and proprietor of the Grand Central Hotel; and Ezra L. Johnson, longtime member of the board of school visitors and Newtown's unofficial town historian; (second row) Allison P. Smith, editor of *The Newtown Bee*; Patrick H. McCarthy, district school teacher and postmaster of the Newtown Post Office; and Robert H. Beers, proprietor of the R.H. Beers store. These men were the movers and shakers—the legendary locals—in 1900 Newtown.

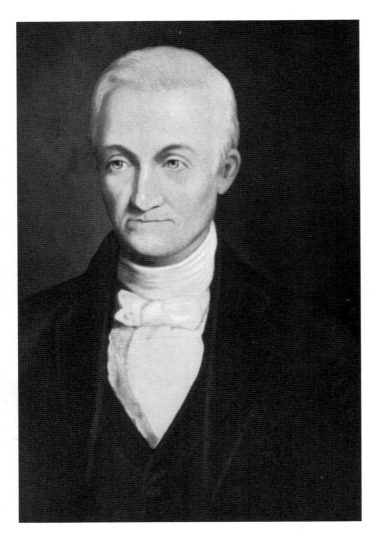

Judge William Edmond
William Edmond (1755–1838) is perhaps the most notable resident of Newtown. As a young man, he distinguished himself in the Battle of Ridgefield, opposing the retreat of the British raiding party after it had destroyed the military stores at Danbury. He was wounded in the leg and lay on the battlefield all night before being discovered and hauled to a neighboring house. The doctors who tended to him were of the opinion that his leg had to be amputated to save his life. However, before they returned to perform the operation, Edmond, using their instruments, operated on himself, opening the wound and exposing the musket ball and bone splinters. Feeling a bit faint, he packed the wound in lint. When the doctors returned, Edmond instructed them in how he wanted the ball and splinter removed. He walked with a limp for the rest of his life, but he walked on two intact legs.

Edmond Homestead, c. 1930 (OPPOSITE PAGE: ABOVE)
William Edmond moved to Newtown about 1782 and practiced law under John Chandler, whose daughter he married. The Edmonds settled in this house on 27 Main Street, which had quarters in the attic to accommodate William's slave, Jenny. He distinguished himself by being elected to the US House of Representatives and became acquainted with Pres. John Adams. Edmonds limited his service in Congress to one term, because Thomas Jefferson, whom he despised, had become president. This house still stands today, just north of the library.

Edmond Town Hall, 1930 (OPPOSITE PAGE: BELOW)
After Jefferson's election, Edmond returned to Connecticut, where he served as the chief justice of the state supreme court. In 1818, the general assembly passed the new constitution, which opposed his Federalist views. Edmond retired to his house in Newtown, where he made himself available to dispense legal advice, free of charge. He is best remembered today for the town hall, built in 1930 by Mary Hawley, his maternal great-granddaughter, and named for him.

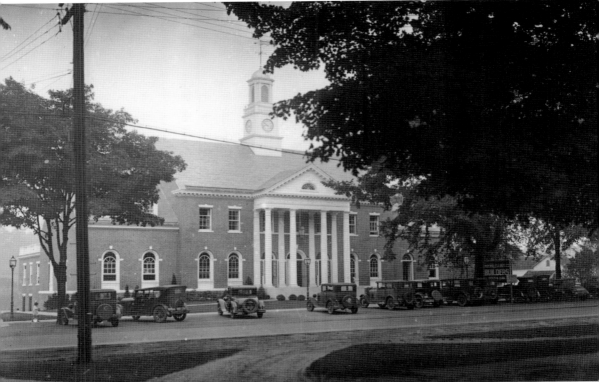

Abijah Merritt

The Merritts were one of the pioneering families of Newtown, and Abijah (1775–1854) was typical of the men who shaped its early years. Abijah Merritt's father, John, was the first of the family to move to Newtown, settling in the southernmost part of town on Pine Swamp Hill, over which Pine Tree Road currently runs.

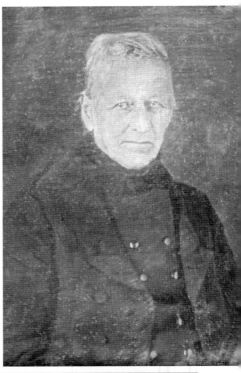

Merritt, shown at right in a c. 1845 daguerreotype, was John's only son. At age 15, he was apprenticed to a cloth-dresser until he reached his majority at age 21. He worked in that trade in Sandy Hook, where, around 1790, he built the house shown below, which still stands at 10 Glen Road. A few years after establishing himself as one of Sandy Hook's most prominent citizens, he left the cloth trade and turned to operating a gristmill. In his middle years, he became active in public affairs, serving nine times as selectman between 1820 and 1838. His reputation for integrity, sound judgment, and his business ability led him to frequently help settle estates of deceased citizens, a job for which he derived a retirement income.

Merritt's daughter, Hannah Sanford Merritt, married Charles Johnson on May 25, 1826, and shortly after became the mother of Ezra Levan Johnson, forging an alliance between two families that would become powerful in Newtown's political, social, and religious life throughout the 19th century.

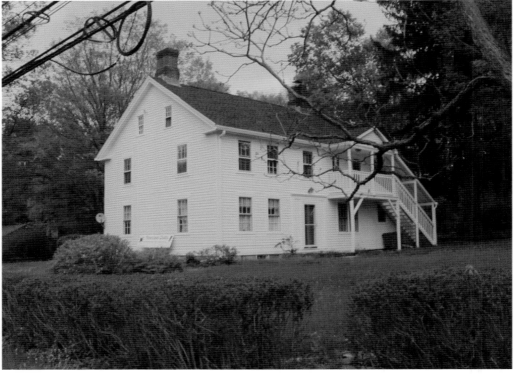

John Beach

John Beach (1701–1782), the second minister of the Newtown Congregational Church, began his ministry in 1724. By 1732, however, he suffered a crisis of faith and came to the conclusion that the Church of England (Episcopal) more closely followed Christian doctrine. He accordingly resigned his ministry and went to Scotland to become an ordained Anglican priest. He returned to Newtown to establish Trinity Episcopal Church. Being a fervent Anglican, he continued to pray for the health of King George throughout the Revolution and remained a vocal Tory. He was the reason for the heavy Loyalist sentiment in Newtown during the Revolution. Because there are no known portraits of Reverend Beach, his headstone serves as a proper memorial in these pages.

David Judson

David Judson (1715–1776), the fourth minister of the Congregational Church, began his ministry there in 1743. He was a leading intellectual in New England, so when John Beach began publishing pamphlets critical of Congregational doctrine, Judson was moved to reply. Thus began a pamphlet war that, at times, became acrimonious and personal. That conflict of words lasted until Judson's death in 1776 from small pox, contracted while he was visiting sick Continental soldiers in Stratford.

Like many leading citizens of the 18th century, Judson was a slave owner. He owned a family of five slaves, who, according to probate documents, lived in the neighboring house to the south, which is known today as the Matthew Curtiss House, the headquarters for the Newtown Historical Society. Note that Judson's headstone has been vandalized. The reason for the mutilation, by five blows of a sledgehammer, is unknown, as is the identity of the perpetrator.

William C. Johnson, 1932

William Johnson was the son of Ezra Johnson (see page 33) and thus a member of one of Newtown's pioneering families. Like others in these pages, William (1862–1944) helped create the town's unique Yankee atmosphere. He learned the rudiments of farming from his father, after which he apprenticed as a carpenter. He was one of the builders of Castle Ronald in the late 1880s (see page 119). After he married, he turned to running the family gristmill and icehouse on the millpond off of the west end of Mile Hill Road.

He was very active in town affairs, serving three terms as first selectman, a two-year term as judge of probate, and as a representative to the general assembly for two sessions. He is seen here portraying Abraham Lincoln on a float in a parade honoring the bicentennial of George Washington's birth.

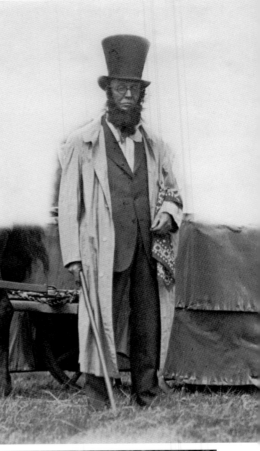

Clearing Roads, 1920

William Johnson made his greatest contribution to Newtown as the state highway supervisor from 1919 to 1934. He was responsible not only for keeping the main roads through town in good repair, but also making sure that they were cleared of snow after several major winter storms during his period. That meant hiring a crew of about 35 men to shovel the roads by hand, as seen in this photograph. These men, working at the top of Mount Pleasant, cleared almost 13 miles over four days.

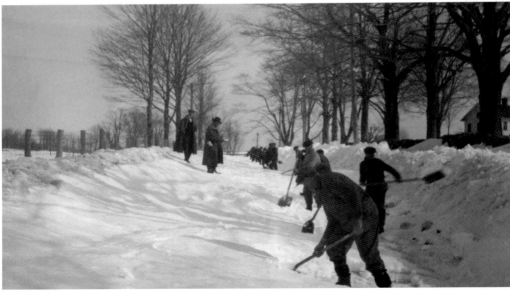

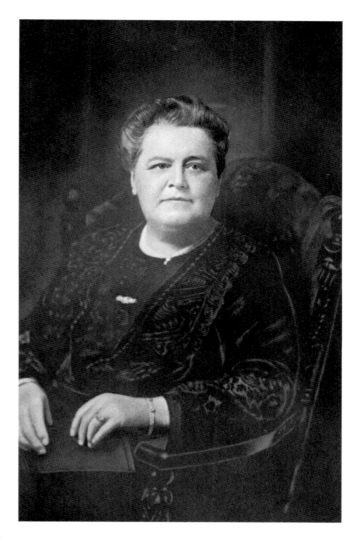

Mary Hawley

Mary Hawley (1857–1930) was Marcus and Sarah Hawley's only child who survived into adulthood. When Sarah decided that the family should move to her hometown after the death of her father, Cyrenius H. Booth, in 1871, Mary became a resident of Newtown and finished her education in the Newtown Academy. After a disastrous marriage, during which she was abandoned by her husband, Mary became reclusive and was rarely seen in town except for occasional furtive walks on Main Street near her home after dark.

With the death of her mother in 1920, Mary became the sole heir of her father's fortune, and she began to come out of her shell. Following the advice of Arthur Treat Nettleton, she arranged to build a new, extremely modern high school and endowed a fund to maintain it, which today still returns small sums of money to the school. Several benefactions followed, including construction of the Edmond Town Hall (named for her maternal great-grandfather) and rebuilding of the entrance of the village cemetery. After Mary's death in 1930, money was deeded to the town to build a spacious, modern library and a monument to stand at the head of Main Street to commemorate town war veterans. The monument was called The Peace and Liberty Monument (although it is currently and mistakenly referred to as the Soldiers and Sailors Monument).

Marcus Hawley

When he died, Mary Hawley's father was probably the wealthiest man in Fairfield County. His fortune derived from the Bridgeport hardware store that his father, Thomas, founded in 1829. When gold was discovered in California in 1849, young Marcus (1834–1900) traveled west and established a branch of the store in San Francisco. He was able to dominate the market for mining tools by mastering the problem of logistics in the era before the Panama Canal was built. Marcus expanded the business, creating branches in Los Angeles and Houston. The profits from these ventures he plowed into the railroad, which, following the Civil War, was in a period of rapid national expansion. This increased his personal wealth considerably. Hawley's obituary proudly proclaims that he crossed the nation 69 times.

Town Hall Cornerstone, 1929

Mary Hawley is seen here in her only public appearance, laying the town hall cornerstone. Hawley School was the only building that she saw completed. She became seriously ill in late 1929, and it was hoped that she would see and participate in the dedication of the town hall, but she died several months before its completion. The bell in the building's cupola tolled for the first time as her funeral cortege wended its way to the cemetery she had restored.

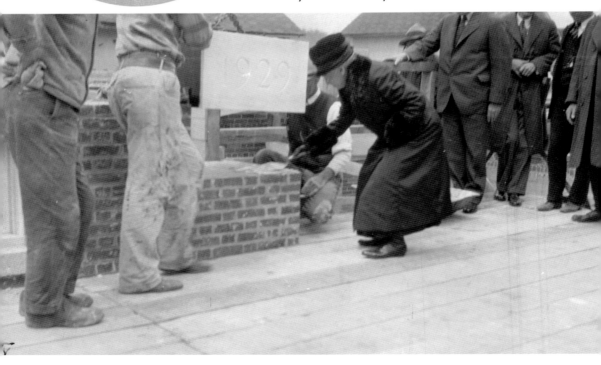

Arthur Treat Nettleton

Arthur Nettleton (1862–1950) was the architect of modern Newtown. Originally from Bridgewater, he came to Newtown as a teenager and lived in the Balcony House (34 Main Street) until his death. In 1898, he was hired as the treasurer of the Newtown Savings Bank, a position that gave him the responsibility for running its day-to-day activities, which he did for the next 52 years. He remained the leading figure in the bank, ascending to the presidency in 1938.

In the 1920s, Nettleton became the financial advisor and friend of Mary Hawley. It was he who advised her to make her first benefaction, the Hawley School, and he guided her other donations to the town. He also served as the head of the building committee for all her donations, guiding their final form.

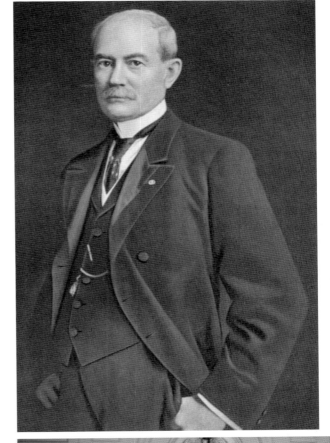

Nettleton's Last Photograph, 1950

Nettleton was passionate about preserving Newtown's famous flagpole, which, since the nation's centennial in 1876, has stood in the center of the intersection of Main Street, West Street, and Church Hill Road. In 1950, he was instrumental in replacing the decrepit third, wooden pole with one of spun steel that was sunk to a depth of 11 feet and anchored in a 7-foot-diameter collar of concrete. Here, Nettleton (left) is being given a slice of the old wooden pole, just a few months before his death. Posing with Nettleton are Paul Cavanaugh and an unidentified woman. This cross section is currently on display in the Local History and Genealogy room of the library he helped to build.

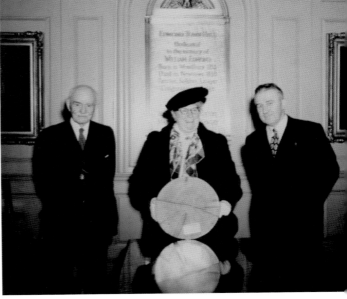

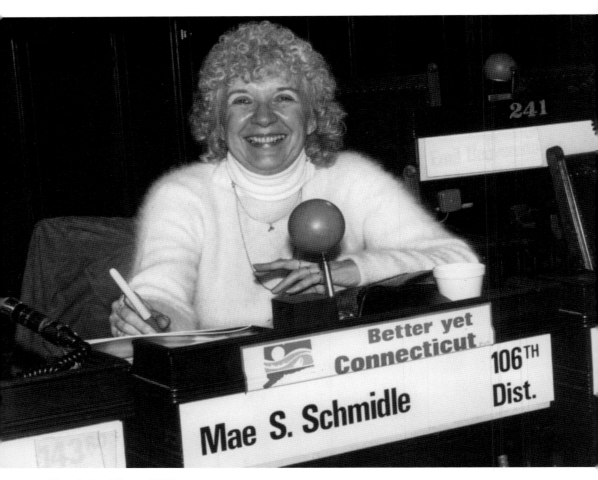

Mae Schmidle, c. 1981

Mae Schmidle has accomplished more in the past 45 years than probably any other Newtown Citizen. She moved into town with her young family in 1964, buying the Glover House, which dates to the first town clerk, John Glover. She immediately became involved in the Hawley PTA and initiated building a library for the school. Adult education was her next innovation, out of which grew the Society for the Creative Arts in Newtown (SCAN). Schmidle then went on to become the president of the state PTA and the vice president of the national PTA. She became involved in local Republican politics, serving as town clerk between 1973 and 1981, during which she preserved many of the town's crumbling records.

It was as representative to the Newtown General Assembly that she made one of her most significant contributions. Long a point of controversy, the flagpole in the middle of the road had been under fire by the Connecticut Department of Transportation, which demanded that it be removed as a traffic hazard. One of her first pieces of legislation in 1981 was to make it law that the beloved monument could not be moved.

Her contributions could fill a small book, but she has distinguished herself most recently by her intense involvement in the Visiting Nurse Association of Newtown. For her longtime role with that organization, she was made the grand marshal of the 2008 Labor Day Parade. (Courtesy of *The Newtown Bee*.)

CHAPTER TWO

Agriculture

Agriculture was the early foundation of Newtown's economy. Initially, subsistence farming dominated, as almost everything needed to sustain a family was produced on the farm. As the country expanded west and the Industrial Revolution began to be felt, the rocky, thin soil of New England's small fields were proving increasingly inadequate to produce enough to support local families. Combined with the coming of the railroad, which put New England at a competitive disadvantage with the Midwest, prices were driven down. This further eroded family income and drove local farmers to pursue other forms of income, often in the factories of larger cities.

By the end of the 19th century, farming in much of Fairfield County was near extinction, but Newtown seemed to buck that trend. To do this, however, it had to turn from raising crops to dairy farming, which could be done more profitably on small, infertile plots. It was more efficient to graze cows and grow silage than to try to raise market crops

The post–World War II era has not been kind to Newtown's farms. As the automobile became ubiquitous, the town became a desirable residential location, driving land prices so high that is was hard for farmers to resist selling to developers at prices that far exceeded what could be raised by farming. A few families, such as the Paproskis and the Ferrises, continued dairy farming. But with falling milk prices, these families have found that they need to offer amusements such as corn mazes and pumpkin-gathering hayrides, and concessions such as homemade ice cream, to earn a living income.

Specialty farming has allowed Newtown's farmers to continue to follow their passion. The owners of McLaughlin Vineyards, for example, have turned to winemaking and producing maple syrup from their own trees in order to continue working on the land. Planter's Choice Nursery produces landscaping bushes, shrubs, and plants to the wholesale market to keep its land sufficiently productive. Several old farms in town have turned to breeding and boarding horses. The clientele for this industry tends to be "high end," allowing the preservation of open farmland. Farming still survives in Newtown but in a form that the town's forefathers would not have recognized.

George Beers

Economically, Newtown was an agricultural town until well into the 20th century. Typical of the farmers who made up the town's basic population was George Beers (1825–1899). In 1849, he married Sarah Peck, a member of another pioneering family, and bought a sizable farm on the south end of Palestine Road on which he worked for the rest of his life. Like many local farmers, he never took an active part in politics, but was a passive member of the Republican Party.

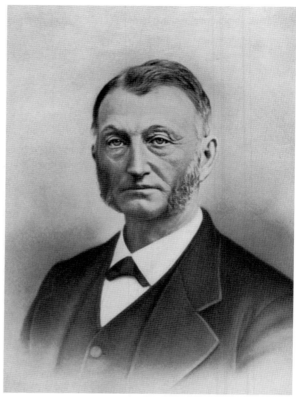

Cherry Grove Farm

Upon George Beers's death, the farm passed to his son Eli, and it became known as Cherry Grove Farm. It is located on Palestine Road, formerly Cherry Street. Today, it continues as an active farm. (Courtesy of Andrea Zimmermann.)

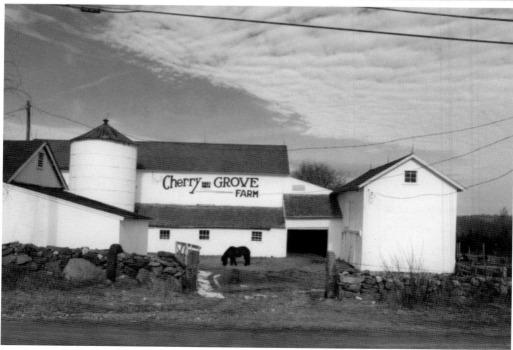

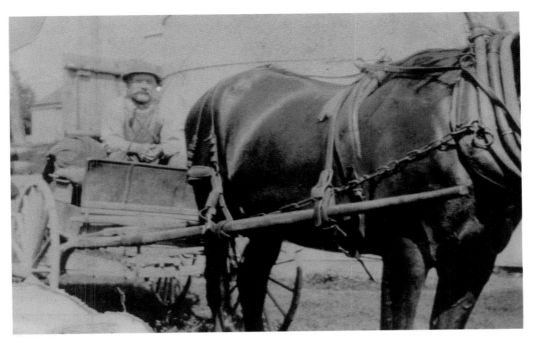

George Mayer Sr.
Eli Beers, George's son, sold Cherry Grove to a German immigrant, George Mayer, around 1890. He paid for most of it with a small inheritance he had received from Bavaria. To get it, he went to the Branchville railroad station and picked up a container of gold coins, which he hid under the seat of the wagon. In 1923, Mayer (1859–1946) exchanged the farm for the house of his son, George Jr., at 65 Main Street.

Eleanor Mayer
George Jr. passed Cherry Grove Farm on to his son, George III, who continued to work it until his death. George's sister, Eleanor, after a successful career in banking and business, took over the farm and continues to work it with the help of hired hands. Eleanor became famous for her displays of farm produce at the Danbury Fair, until it closed in the early 1980s. (Courtesy of *The Newtown Bee*.)

Theron Platt

Platt (1848–1927) was born and lived his whole life on the family homestead in Poverty Hollow. He was known nationally as a scientific farmer and as a recognized authority on all matters relating to the potato. In one year, he raised 450 varieties of the tuber in order to conduct tests on them, one of the results of which was the discovery and publication of the cause of potato scab. His only son, Philo Platt (1880–1928), was also well known in agricultural circles and became Newtown's first commissioner of the Connecticut State Board of Agriculture.

Shirley Ferris

Shirley and her husband, Charles, have continued to work the Ferris farm on Route 302. It has been in the family since 1864. To make the farm work in a modern world, they have turned from raising fruit crops to dairy farming and, more recently, to selling ice cream made from their cows' milk. For eight years, Shirley Ferris served as a commissioner to the Connecticut State Board of Agriculture, as had Philo Platt before her. (Courtesy of *The Newtown Bee*.)

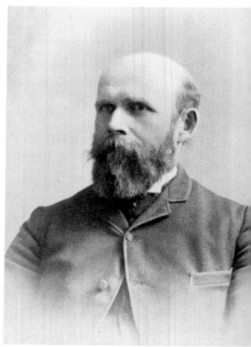

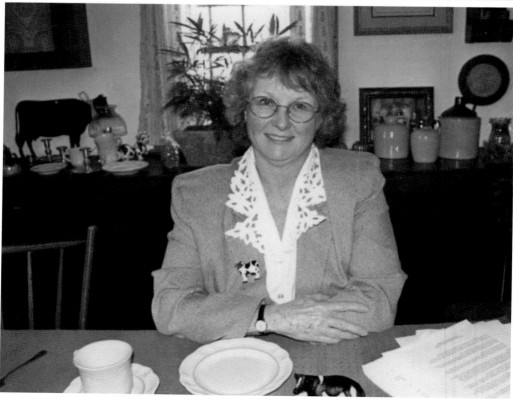

Homer Clark

The Clark farm was called Arcadia, for reasons that no one now remembers. It was located on the east side of Route 34, directly across from the entrance to Great Ring Road. Under Homer Clark (1862–1951), the farm specialized in raising animals that he would butcher for their meat, the type of specialty farming that characterized Newtown agriculture in the 20th century. Homer's son George Sr. continued the family tradition as a meat-cutter for Hawley Warner in his store, The Red Brick Store, in the center of Sandy Hook, until Warner's retirement in 1978. (Courtesy of George Clark Jr.)

The Burr & Clark Meat Wagon, c. 1910

George U. Burr (1885–1962) was a neighboring farmer who formed a partnership with Homer Clark in the meat business. They would butcher on Clark's farm, pack the meat in ice, and travel a regular route in southern Newtown and northern Monroe, selling the meat. They would further cut the meat to order for those who lived along the route. The man holding the horses is Homer Clark. (Courtesy of George Clark Jr.)

Bruce McLaughlin

Bruce McLaughlin's parents purchased a large farm off Albert's Hill Road in 1930, but it was Bruce and his wife, Taffy, who, in 1979, took 15 acres of that farm and planted grape vines that would produce red and white wines. This was the beginning of McLaughlin Vineyards, an example of the specialized farming that was capable of succeeding where traditional agricultural was moribund. Bruce is seen here around 1995. (Courtesy of McLaughlin Vineyards.)

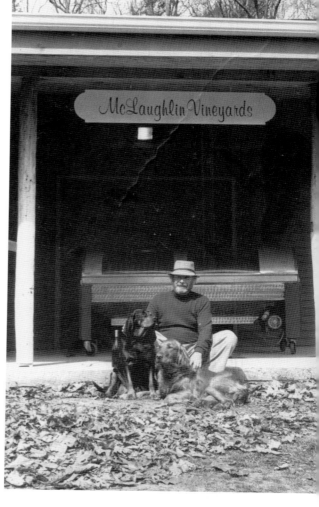

Morgen McLaughlin

Morgen, Bruce McLaughlin's daughter, seen here around 1995, once described herself as a "black sheep," since she had no desire to go into the family wine business. She went to college in Boston, majoring in business. But, while taking time off before starting her master of business administration degree, she decided to work in the vineyard, which up to that point had not turned a profit. She was hooked, and managed to turn the business around with efficient management and diversification into such products as vineyard-produced maple syrup. (Courtesy of McLaughlin Vineyards.)

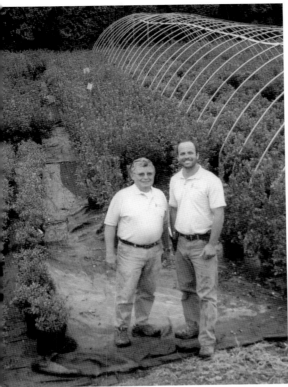

Charles Newman

Charles Newman's grandfather and uncle were dairy farmers in the Huntingtown District, which had been settled by Jewish Russian immigrants beginning around 1905. Charles graduated from local schools and went on to earn a degree in animal husbandry at the University of Connecticut. After returning to get a degree in nursery management, he began planting trees and shrubs to sell to the wholesale market in 1969, and he has been expanding ever since. Charles (left) is seen here around 2010 with his son Darryl, who is continuing the business into the next generation. (Courtesy of Charles Newman.)

Planter's Choice Nursery

This photograph shows the main portion of Charles and Darryl Newman's nursery business. Huntingtown Road runs across the lower portion of the image, which is looking to the west. The nursery operation consists of 100 acres, including the land shown here and a parcel running between Meadowbrook and Bare Hills Roads. Another 100 acres is in Litchfield County. (Courtesy of Charles Newman.)

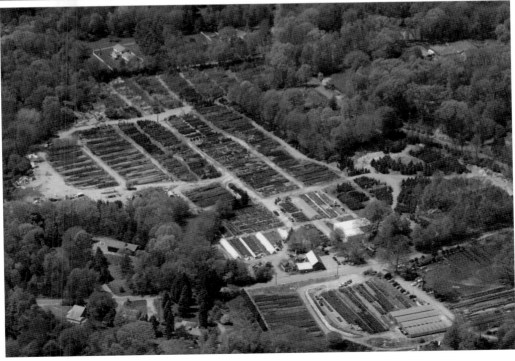

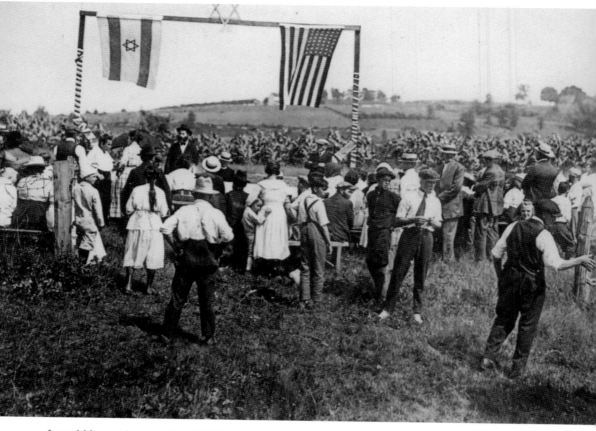

Israel Nezvesky and the Old Synagogue

The spiritual center of the southern Huntingtown Jewish community is its synagogue. It was built in stages on land donated by Israel Nezvesky, beginning with the ground-breaking shown here in 1914. The cornerstone was laid in 1919, and the building was dedicated in 1920, replacing the private homes in which services were previously held.

The community began with the immigration of several Russian Jewish families made possible by Baron Maurice de Hirsch, a wealthy Bavarian Jew who helped finance several of these immigrant communities in Connecticut and New Jersey. Among the first of the Newtown settlers was Israel Nezvesky (1847–1925), who had originally owned a tavern in Russia. With the growing anti-Semitism in Imperial Russia at the beginning of the 20th century, he left his homeland and ended up in Newtown by 1906. He became a leader in the community. Nezvesky not only endowed the land on which the synagogue was built, but he also purchased its first Torah, at a cost of $250, a considerable sum for the time. In gratitude, the synagogue was named Adath Israel, meaning the "House of Israel." Regrettably, there is no known photograph of Nezvesky.

The synagogue was substantially modified in 1957. The building was raised to install a basement with kitchen facilities that could be used for social occasions and as a Hebrew school. In addition, the building was equipped with heat and water for the first time. With a growing membership, pressure was placed on this renovated structure, and plans were drawn up for an entirely new synagogue on a lot to the south of the venerable old building. It was constructed and finally dedicated in 2007.

During the Depression, low farm incomes were supplemented by turning farmhouses into *kochlalains* ("cook for yourself"). Families from New York rented rooms, cooked their own meals in the kitchen, and ate in the dining room. Thus, agriculture survived on lower Huntingtown Road.

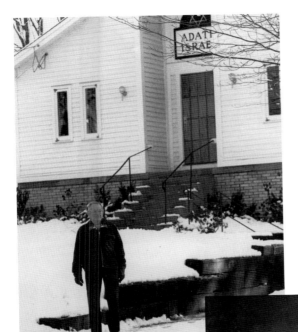

Sam Nezvesky, 1988
Samuel Nezvesky (1920–2010) is the grandson of Israel. As with other Jewish families of Huntingtown Road, he became the third generation patriarch of his family and also of the community. He was originally a dairy farmer, but, needing to supplement his low income, he became known throughout the town for his carpentry and painting skills. In retirement, he turned to Christmas tree farming to supply seasonal income. He is seen here standing in front of the "old" synagogue.

Jacob Goosman
Jacob Goosman (1888–1961) also became a community patriarch and leader upon his arrival in Newtown, about 1908. Having been a declared Bolshevik in early-20th-century Tsarist Russia, he had a substantial price on his head, and this led directly to his emigration. He is seen here around 1905 with his wife, Sophie, and eldest sons Meyer (left) and Harry. He, like Israel before him, became a dairy farmer.

Tom Goosman, c. 1935

Tom Goosman (1916–2005), Jacob's youngest son, became a venerated leader in both the community and the town. After surmounting the anti-Semitism of his youth, Tom went on to serve as selectman between 1968 and 1978 and befriended almost all of those who knew him. With his wife, Lilly, he met with community leaders in 1949 to form the Botsford Fire Company. Tom was also part of the first committee, formed in 1941, to create the Newtown Ambulance Company and served on the town's first police commission.

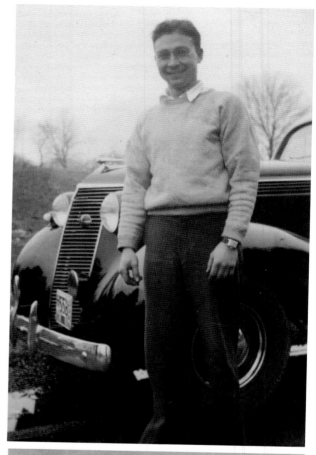

Vincent Gaffney

Beginning in 1937, Gaffney (1909–1973) was the teacher of the vocational agriculture program at Hawley School, giving potential farmers in town the rudiments of successful farming practices. He had graduated from the University of Connecticut, which was a Land Grant College founded just after the Civil War to promote efficient farming practices and improve the quality of American agriculture. He headed the vocational agriculture program until it was discontinued in 1961, at which time agriculture students were transferred to Woodbury. Gaffney continued teaching math until his death.

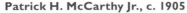

Patrick H. McCarthy Jr., c. 1905

Patrick's father, also named Patrick (1872–1920), came from County Clare in Ireland and bought a small farm in 1858 on what is today Woodbine Lane. A good deal of both the farm and road disappeared when Route 84 was built. In 1914, Patrick Jr. (1872–1914) bought the house at 51 Main Street, which is where he lived during his career as a local district schoolteacher and postmaster.

Welcoming Home Soldiers, 1919

Patrick McCarthy Jr., seen here on the extreme left, with top hat and spats, orchestrates his schoolchildren as they welcome soldiers returning from World War I. In 1919, the town turned out in large numbers to welcome home its veterans with a parade and speeches. McCarthy organized the children, as he had in 1905 for the town's bicentennial parade (see page 11).

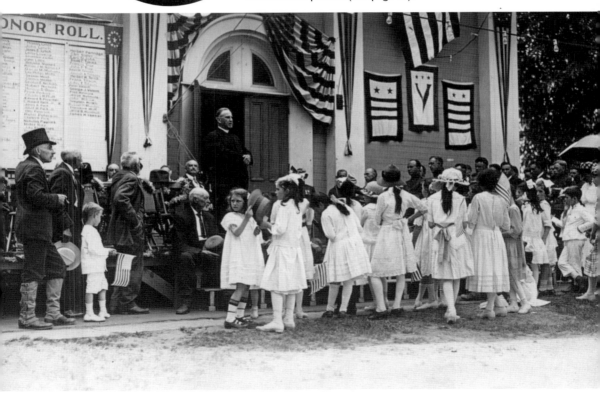

Annie Murphy
Murphy, seen here around 1912, was a district schoolteacher. Little is known about her, but from this photograph and the histories of her contemporaries, one can assume that she was very young, either just out of the district school or with a year or two of training at the state normal school at Danbury. She must have been unmarried, since, by law, married women were barred from teaching.

Half Way River School, c. 1912
This rare interior photograph of the Half Way River School, once located on Route 34 just above the Monroe boundary, shows the relatively small class size and diverse ages of Murphy's students. Note the Newtown map on the rear wall. This was drawn by Daniel Beers (see page 66), who came out of retirement to produce a map with the locations of all of the town's families for Newtown's bicentennial in 1905.

Charles S. Platt, c. 1905
Charles Platt (1842–1908) was Newtown's man of music. He was the organist at Trinity Church at the turn of the century. Platt studied music in Europe and became a teacher of considerable prominence in the region. He was also renowned for putting together musical ensembles and choirs of local talent and organizing musical entertainments of all sorts.

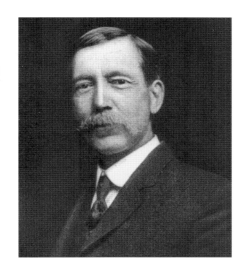

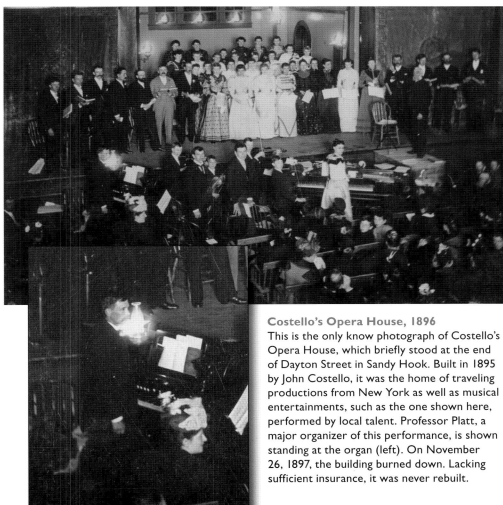

Costello's Opera House, 1896
This is the only know photograph of Costello's Opera House, which briefly stood at the end of Dayton Street in Sandy Hook. Built in 1895 by John Costello, it was the home of traveling productions from New York as well as musical entertainments, such as the one shown here, performed by local talent. Professor Platt, a major organizer of this performance, is shown standing at the organ (left). On November 26, 1897, the building burned down. Lacking sufficient insurance, it was never rebuilt.

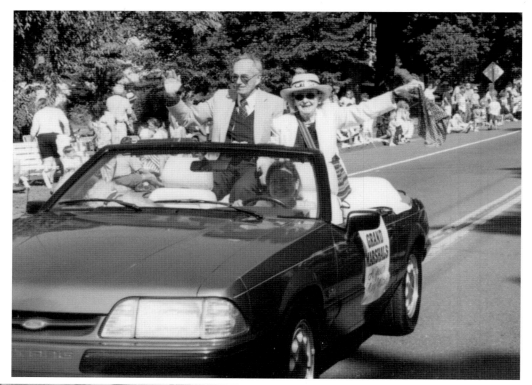

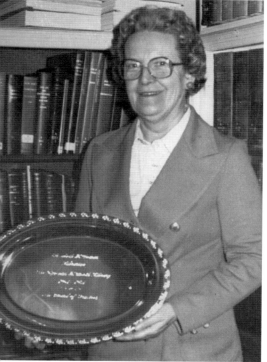

Mary Mitchell and Al Goodrich
Mary Mitchell came to Newtown in 1987 and immediately became interested in its human and natural history. Her association with Al Goodrich began when she joined the Flag Pole Photographers. His passion for drawing maps, combined with her passion to publish, resulted in the first *Newtown Trails Book*, which has gone through four subsequent editions. Their interest in old houses resulted in the publication of *Touring Newtown's Past* and led them to be picked as grand marshals for the 2001 Labor Day Parade.

Betty Downs
Betty Downs, seen here in 1981, did not possess a degree in library science, but instead apprenticed under Sarah Mitchell, who was the librarian of the Cyrenius H. Booth Library from 1955 to 1971. While working under Mitchell, Downs developed an intimate knowledge of the collection and of library management. After Downs took over as head librarian in 1971, her passion for the library made it one of the premier educational institutions in the area and positioned it to enter the electronic world by the time of her retirement in 1981.

CHAPTER FOUR

Health

There are probably no persons more important to Newtown than its doctors and other men and women of healing. Although medicine as it was practiced in the 18th century was primitive by modern standards, it afforded hope and solace to townspeople. It was considered so important that a plot of land and a house on the Ram Pasture was promised to Isaac Tousey as an inducement for this man of considerable surgical knowledge to settle in the area. That he was also an ordained Congregational minister strengthened the perceived need to have him in town, but it was his medical knowledge and skill for which he was most wanted.

From the end of the 18th century through the middle of the 19th century, medicine was practiced in Newtown by men whom Ezra Johnson called "doctors of the old school." These men usually apprenticed under one of the town's older, established physicians and then supplemented that practical experience with lectures in New York or New Haven on the latest discoveries and techniques. Often, these lectures were given by the leading men in the field, and Newtown benefited by being in close proximity to the cities where these men taught and practiced. One of the best examples of these doctors was Cyrenius H. Booth, the grandfather of Mary Hawley and namesake of the library.

Toward the end of the 19th century, women began to join the ranks of men as healers. Women with special knowledge of herbal remedies were always part of the town's healing personae. A woman known only as Aunt Park is one example. Some of these women had roads named after them, and others exist as part of the town's folklore. They are truly legendary, but little is known of their lives, and no images remain to be included in a volume such as this. Celestia Benedict (1840–1922) received formal training in medicine at The Woman's Medical College of Pennsylvania, graduating in 1874. She practiced medicine, first in Newtown and then in Bridgeport. Regrettably, no images of her exist either.

The field of health is extended here to include animal medicine. In a farm community, the ability to cure large animals is especially important. Thus, Russell Strasburger became an important member of the community as a large-animal doctor from the late 1930s to the 1970s. He was also an early member of the Ambulance Association, so his healing extended into several categories.

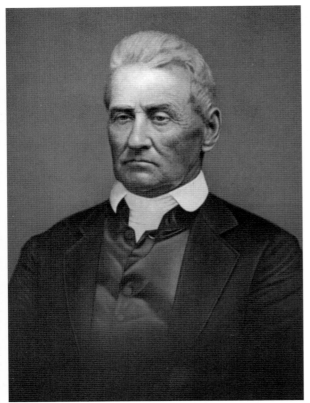

Cyrenius H. Booth

Dr. Booth (1797–1871) was one of the "doctors of the old school." He studied medicine with Newtown physician Bennett Perry (1755–1821) and then attended a long course of lectures by Dr. Hosack of New York, a leading man in the profession at the time. In 1820, Booth married Sarah Edmond, daughter of William (see page 12), and built the house at 19 Main Street, which would later become the home of Mary Hawley and her mother, Sarah, who were Booth's granddaughter and daughter, respectively.

The Booth/Hawley Homestead, c. 1935

After Dr. Booth's death in 1871, his daughter Sarah Hawley decided that she wanted to move back to her childhood home. She completely remodeled her father's house, nearly doubling its size and incorporating the original building within it. After Mary Hawley's death in 1930, it became a series of inns under the name Hawley Manor. Recently, while being renovated into the Inn at Newtown, the south wall of Booth's house was found inside the interior wall of the bar.

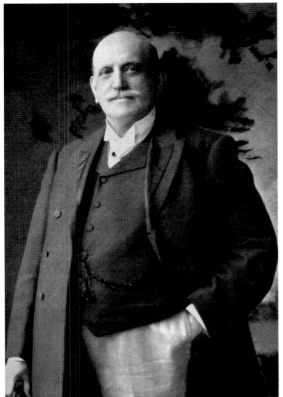

Dr. William Conrad Wile, 1905

Dr. Wile (1847–1913) was the primary care physician in Sandy Hook between 1873 and 1886. He was a Civil War veteran, having fought at Gettysburg and with Sherman in Georgia. As a result, he became one of the founding members of Newtown's Grand Army of the Republic in 1878. While in Newtown, he developed a proprietary medicine that could relieve the symptoms of lead poisoning, much to the relief of workers at the New York Belting & Packing Company.

William Wile Home, c. 1885

The precise location of this Sandy Hook house is uncertain, but it is known that Dr. Wile lived here until 1886, when he moved to Danbury. There, he continued to produce *The New England Medical Monthly*, an internationally recognized journal. He also founded the Vass Chemical Company, which continued to produce Thialion, his mysterious cure for lead poisoning. With the proceeds of his business, he built Terrywile, the estate on South Deer Hill Avenue that is now a Danbury town park.

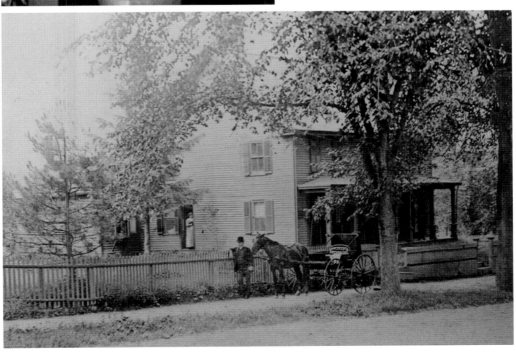

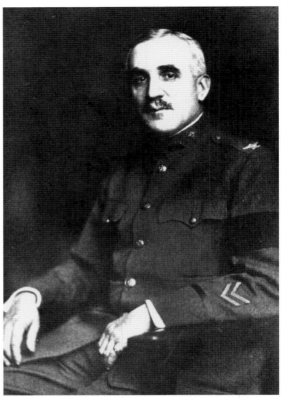

Dr. Charles H. Peck, c. 1918

Charles Henry Peck (1870–1927) was considered the greatest surgeon in New York City. He was educated at the Newtown Academy and then graduated first in his class from Columbia University in 1892. His time in private practice was short, but he continued to serve as a consulting surgeon for countless hospitals in New York and southeast New England. When World War I broke out, he was made a lieutenant colonel and became the consulting surgeon for the entire American Expeditionary Force. In 1939, the Veterans of Foreign Wars in Newtown dedicated its post to him and his son, who died during the war.

Dr. Waldo Desmond, c. 1980

Dr. Desmond (1898–1987) served as an intern under Charles H. Peck in New York City. Two years after graduating from Yale University in 1925, Desmond came to Newtown and continued in private practice until retiring in 1968. He was a pivotal factor in getting the Fairfield Hills State Hospital for the mentally ill located in Newtown, and he served on its staff until his retirement. He was deeply committed to the town. Desmond has been credited with delivering 3,000 babies during his career.

Dr. Thomas Draper, c. 2000
Dr. Draper was mentored by Dr. Egee when he came to town in 1959 and set up his pediatric practice on Main Street. Draper became Newtown's health director when Egee retired from that post in 1965, and he served for 29 years. His interest in public health drove him to become a passionate advocate for sidewalks at the center of town, both for their impact on fitness and also for the social effects of meeting and talking to neighbors.

Dr. Benton Egee, c. 1996
Dr. Egee's career began as a general practitioner and family physician in Newtown in 1935. He continued to practice here until 1965, when he went to Danbury Hospital to create and develop its emergency room, which was a new concept at the time. He was also responsible for setting up the Newtown Health District, which focused attention on the problems of public health in general. Although he retired from medicine in 1980, he remains one of the best loved of Newtown's modern doctors.

Dr. Robert Grossman, c. 2000
Dr. Grossman came from a family of doctors, so it is no surprise that he became a surgeon. In the early 1960s, he opened an office in Newtown. To supplement his income while he established his practice, Grossman began working for Fairfield Hills State Hospital. By 1961, he became the primary surgeon there, continuing until the operating theater burned in 1974. In 1965, he took over the position of medical examiner from Benton Egee and continues that practice to the present day, although he retired from active surgery when he reached the age of 70.

Dr. Ralph Betts and Family, c. 1883
Ralph Betts (1841–1906) was the first physician in Newtown to specialize in dentistry, setting up his practice in Sandy Hook just after the Civil War. He continued in practice until his retirement in 1893. The members of the Betts family are, from left to right, Ralph Jr., Ralph (holding William E.), James, Mary Jane (holding Gus A.), and Charles.

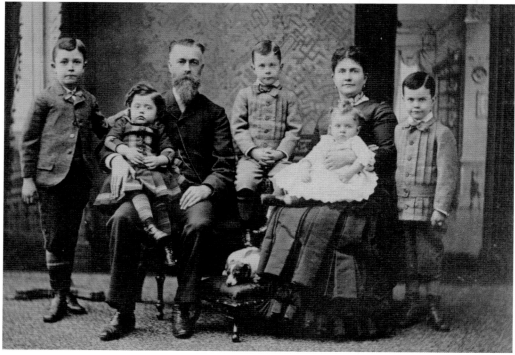

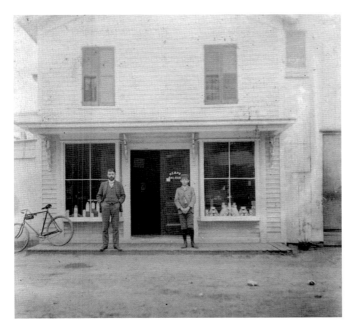

Betts and Betts Drugstore, c. 1905

Two years before his retirement, Ralph Betts went into business with Mortimer Terrill in this grocery and general store. In 1902, Betts bought out his partner and brought his son Ralph Jr. into the business. The younger Ralph was somewhat mentally deficient, and the store became a means for him to generate income with his father's help. A balcony was added around 1917, and today the building houses Porco's Karate Studio.

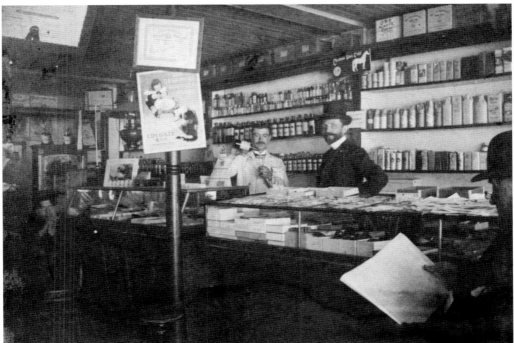

Interior of Betts and Betts Drugstore, c. 1905

In 1902, with his son as a partner, Ralph Betts Sr. added the drug business, which continued under his successor, Arthur "Doc" Crowe, until shortly after World War II. This rare interior photograph shows Ralph Jr. compounding a liquid medicine in the days before prescriptions were needed. The man to the right of Ralph is unidentified, as are the figures on the extreme left and the extreme right.

Russell Strausburger, 1931

Strausburger (1914–1999) moved to Newtown with his family when he was 15 years old. After graduating from Newtown High School, he went on to earn a veterinary degree and returned to town in 1936 to build the Newtown Animal Clinic at 98 South Main Street. Being primarily a large-animal doctor, Strausburger got to know virtually all of the farmers in the area.

Newtown's First Ambulance, 1942

Strausburger was one of the most involved citizens of Newtown. He is seen here (right) with Newtown's first ambulance, which he had just driven to town. He was the president of the Rotary Club, which had started the campaign to get the emergency vehicle. A longstanding member of the Men's Club (see page 120), Strausburger was so well known that he served as at least an honorary pallbearer at the funeral of virtually every town leader in the second half of the 20th century. Joe Ringer (left) was the head of the newly formed Newtown Ambulance Association.

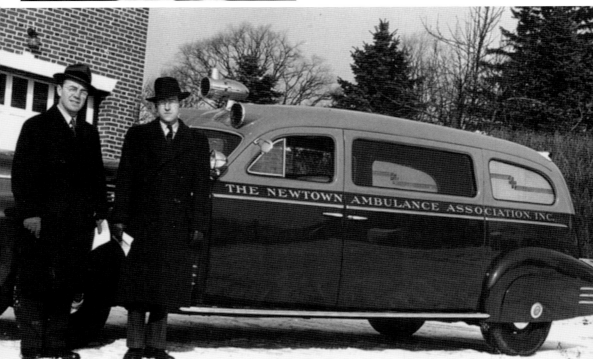

CHAPTER FIVE

Worship

From its founding, Newtown's spiritual life was central to its existence. Its churches were much more important than they are in today's more secular times. Only a single denomination existed in the first 25 years, the Puritans, or, as they became known, the Congregational Church. A revolution occurred in 1732, when the second minister of this church, John Beach (see page 15), converted to Anglicanism, more commonly known today as Episcopalian, and founded Trinity Church. Until the early years of the 19th century, these two denominations were the only ones in Newtown. Well into the century, they dominated the spiritual life of the town.

Ministers such as Congregationalist Rev. Henry Bragg Smith were well respected in town, but he was also important because his sons returned to Newtown to found a newspaper dynasty that survives to the present. Smith's great-grandson Scudder Smith continues to be the publisher of the weekly *The Newtown Bee* and also of the daughter publication, the internationally known *Antiques and Arts Weekly*. As a result, this family is included in this section even though the spiritual needs of the town were met by the newspaper only through the articles written by the town's ministers, such as Rev. Otis O. Wright.

Religious figures other than the ministers of the local churches have also achieved legendary status. Such is the case of Frederick F. Johnson, who became a bishop in the Episcopal Church and served in the Western states before becoming bishop of South Dakota, where he developed the church's educational outreach to the Plains Indians. He was a product of the Johnson family, whose members' legendary status has been commented on elsewhere.

Other denominations developed, such as the Methodists, who still maintain a presence in Sandy Hook, and the Baptists, who died out in the early years of the 20th century. The Roman Catholic church, which developed in the middle of the 19th century as the Irish population of the town rapidly increased, became a strong presence, with such men as Rev. Patrick Fox becoming true legendary locals.

There has been a proliferation of more evangelical denominations in the last decades of the 20th century. Still young, they have not yet produced legendary locals. But they show the promise of doing so.

Henry Bragg Smith, c. 1870
Reverend Smith is typical of the ministers who served the Newtown Congregational Church during the 19th century. A West Springfield native, he was called by the Newtown church's membership to come from Burlington, Connecticut, to be their minister. He also served as church clerk and superintendent of the Sunday school. Smith's tenure here was short, lasting only six years before he was called to serve in Greenfield Hill, but his children formed a Newtown newspaper dynasty that has lasted to the present.

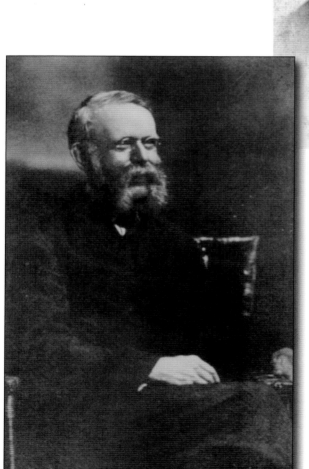

Reuben H. Smith, c. 1905
While working on a newspaper in Springfield, Massachusetts, Smith heard that *The Newtown Bee*, a weekly paper established in 1877, was for sale. He acquired the newspaper in 1880, bought out its rival, the *Newtown Chronicle*, and reformed the newspaper so that it was published on a regular and reliable basis. In 1892, he sold the newspaper to his brothers Alison and Arthur and went briefly to seek greener pastures in California.

James H. George, c. 1905
Reverend George (?–1917) was the very popular rector of Trinity Episcopal Church in the opening years of the 20th century, serving from 1902 until his much-lamented death in 1917. He was heavily involved in town activities as a member of the Men's Club (see page 171), during which he served on the executive committee planning the Newtown bicentennial celebration (see page 11).

Otis Olney Wright, c. 1905
Reverend Wright (1844–1919) served as the pastor of St. John's Episcopal Church beginning in 1891. In addition to serving the spiritual needs of the working families of Sandy Hook, he was passionately interested in the cultural life of his parish. Early in his ministry, he formed the Sandy Hook Free Library, which competed with the subscription library of the Newtown Library Association on Main Street. He was also widely known for his frequent uplifting articles in *The Newtown Bee*. He retired in 1912 to his hometown of Swansea.

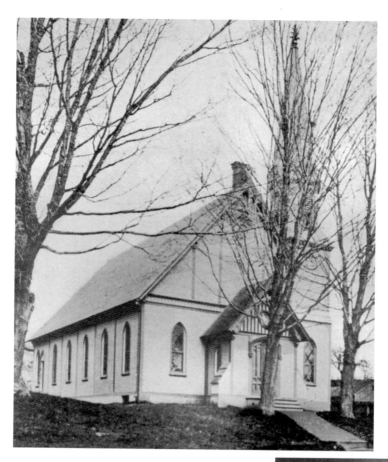

St. John's Episcopal Church, c. 1920
St. John's was founded in 1869 as a chapel of Trinity Church to serve the needs of the Episcopal population of Sandy Hook. It became a separate parish in 1880. From the beginning, it was that village's spiritual and cultural center, as exemplified by Reverend Wright's ministry there. The building shown here was destroyed in a disastrous fire in 1929 and was replaced by the present stone church a year later.

Frederick F. Johnson, c. 1905
Bishop Johnson (1866–1943) was the son of Ezra L. Johnson (see page 33) and is the only citizen of Newtown to reach the level of bishop in the Episcopal church. He was elevated to that position in 1905 with a grand ceremony at Trinity Church. This was also the year of the town's bicentennial, so it was an unusually eventful year for Newtown.

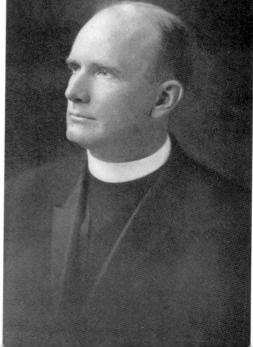

Johnson and Indian Girls, c. 1910

With the death of Bishop William H. Hare in 1909, Johnson took over as the bishop of South Dakota. The following year, he became the bishop coadjutor of Missouri. While in South Dakota, he became vitally interested in education among the Plains Indians, especially the Sioux. Here, he is seen with girls from the Rosebud Reservation, who were being educated under the bishop's guidance.

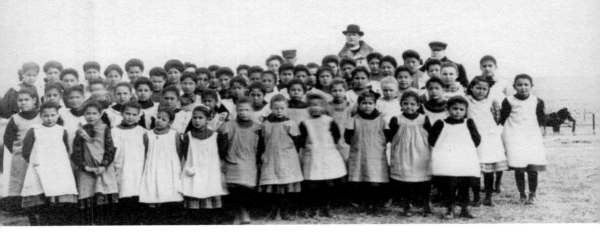

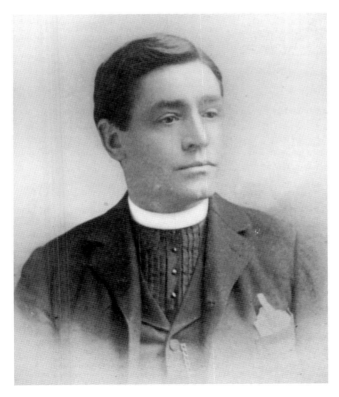

Patrick Fox, c. 1900

Reverend Fox (1878–1939) was the sixth and longest-serving pastor of St. Rose of Lima, Roman Catholic Church. He arrived in Newtown in 1891 and, by the time of his departure in 1910, had built St. Mary's Parochial School in Sandy Hook as well as a school in St. Patrick's Hall, behind the church on Church Hill Road. These schools were run by the Sisters of Mercy, whose convent stood just to the west of the church. Reverend Fox was also responsible for building the rectory in 1895, which is still in use today.

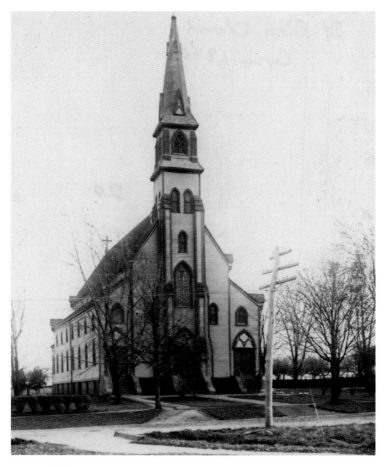

St. Rose of Lima, c. 1920

The first Roman Catholic mass in Newtown was probably the one celebrated by the chaplain of Rochambeau's French army, which stopped briefly in Newtown on July 1, 1781, on its way to Yorktown to aid the Colonists in the Revolutionary War. Regular masses would wait until the early 1850s, when the Irish population had become large enough to support a Catholic church. The Newtown Church was formally organized in 1859 by Rev. Francis J. Lenihan, who spent the next three years setting up the parish.

The first masses were held in the old Methodist church building on South Main Street, but the first permanent church was the old Universalist Church building, also on Main Street. The structure had been purchased in 1855 by an intermediary, because no Protestant Newtown citizen would sell property to Irish Catholics. This first church was located where the exit driveway for the Edmond Town Hall is today. The building continued in use until the church building seen in this photograph was erected in 1883, at which time the old church became the town hall for Newtown. The church seen here remained in use until the parish grew so large that a bigger structure was needed. By 1969, this old building had been torn down and replaced by the current one.

The two schools begun under the tutelage of Reverend Fox suffered a radical setback in 1901, when the New York Belting & Packing Co.'s rubber plant on Glen Road, a major employer of the Irish of Sandy Hook, moved out of town. The drop in the Catholic population resulted in the closing of St. Mary's school and the consolidation of the school population in St. Patrick's. Catholic schooling continued in this way until 1955, when the current St. Rose School building was constructed, under the guidance of Rev. Walter R. Conroy.

CHAPTER SIX

The Arts

Newtown has always benefited from its proximity to New York, serving as a rural retreat for the cultural mecca's artists and entertainers. This was especially the case in the 20th century. Many considered Newtown a weekend refuge, and some, charmed by the town's bucolic atmosphere, came to live here and become a part of the town.

Wilton Lackaye and his wife, Florence, for example, left Broadway and effectively retired to Sandy Hook in 1929 to become antiques dealers and auctioneers. They also became involved with the town's need for athletic opportunities for its young people, forming the Sandy Hook Athletic Club (SAC), which dominated town athletics in the 1950s and 1960s. Likewise, Mac and Virginia Lathrop retired from the vaudeville circuit in 1952 and came to Newtown, where they established a school of dance that is still an important part of the town's culture. Internationally known operatic singer and sometime film personality Grace Moore chose Newtown to be her home in the late 1930s. She became a local legend, although her involvement in the town's affairs was cut short with her premature death in a 1947 plane crash.

In the visual arts, the town has been a refuge in which creative energies can be nurtured. John Angel, for example, bought an old mill that had been converted into a house, next to which he built a large, specially reinforced studio capable of holding 16- to 18-foot-tall slabs of stone that he transformed into monumental statues. These would adorn the facade of St. John the Divine in New York as well as many other nationally renowned buildings. Whereas Angel's reputation was international, David Merrill's was local. He painted murals that decorated the town halls of central Fairfield County. These works are equal in artistic merit to Angel's sculptures.

Likewise, Newtown has attracted writers. Poet and anthologist Louis Untermeyer chose to retire here, becoming one of the founders and guiding lights of the Newtown Historical Society. The rural nature of the town has attracted such nationally known writers as William Swanberg, Justin Scott, and, most recently, Susanne Collins. In a more specialized genre, Bruce Degen and Steven Kellogg illustrated popular children's books. All of these writers have been active in Newtown, but space limitations keep them from being included here.

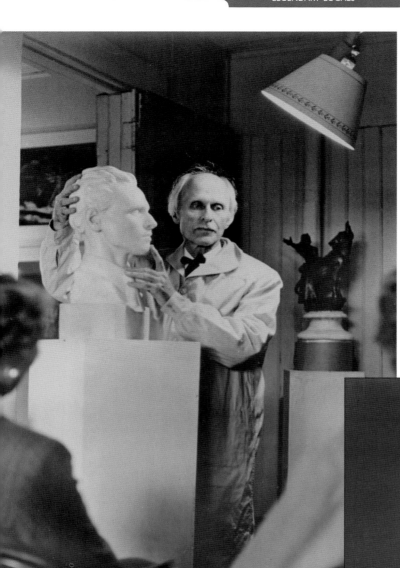

Archangel Michael, 1932
This nine-foot granite statue of the Archangel Michael at the Day of Judgment was done for the Cathedral of St. Johns the Divine in New York. It stands at the apex of the gable over the north tower portal and was heavily influenced by the sculptures that adorn Europe's great Gothic cathedrals. This piece is typical of the output of John Angel's Newtown studio.

John Angel, c. 1950
Angel (1881–1960) was nationally known for his sculptures, most notably those at St. John the Divine in New York. From 1925 until 1953, he produced almost 140 sculptural figures to adorn its facade. He began his association with Newtown in 1940, when he bought the converted Warner gristmill that stood on Old Mill Road, in the Zoar section of town, and made it his home. Next to it, he built a studio that was specially reinforced to handle the 16- to 18-foot blocks of limestone that were so often the medium in which he worked.

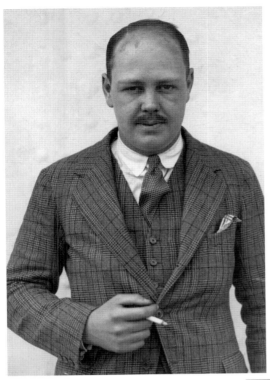

Wilton Lackaye Jr., c. 1928
Wilton Lackaye (1902–1977), the son of actor Wilton Lackaye Sr., followed his father into the profession as both an actor and writer. He appeared in several Broadway plays between 1921, when he performed with his father in *Trilby*, and 1926. During these years, he met his wife, Florence Johns. In 1930, they both retired from the stage and moved to Newtown, where they set themselves up in the antiques business. They also became involved with the town's youth and founded the Sandy Hook Athletic Club (SAC) in 1946 (see page 104).

Florence Johns Lackaye, 1926
Under the name Florence Johns, Lackaye (1890–1986) enjoyed a successful acting career in New York, appearing in more than 17 plays beginning in 1917. Her last performance was in 1929, after which she retired with her husband to Newtown. In addition to helping in the antiques business, in 1950, she bought the land that would house the playing fields, swimming hole, and clubhouse for the SAC.

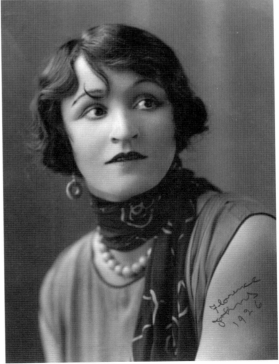

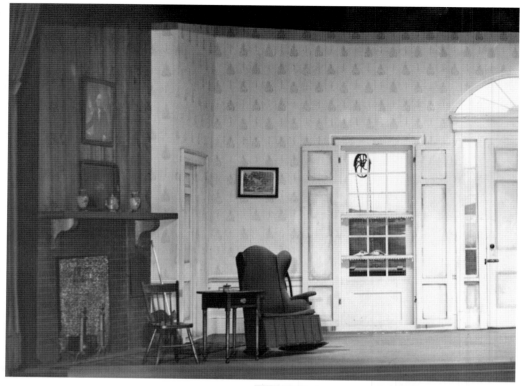

American–Very Early, 1934
In 1934, Wilton and Florence Lackaye cowrote a play about the adventures of an antiques dealer from New York living and trying to do business in Yankee Connecticut. Florence came out of retirement to take the lead role. Its predominant set is shown here. The reviews were mediocre, and the play ran only a week before closing.

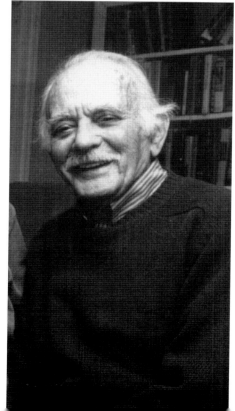

Edward Eliscu, 1995
Eliscu (1902–1998) was a playwright, screenwriter, and lyricist. He was active on Broadway in the 1920s, where he had begun acting with Helen Hayes. He soon turned to writing and became an important film writer after being brought to Hollywood by RKO in the early 1930s. He became the president of the Guild of Authors in 1968 and served in that position for five years. He was inducted into the Songwriters Hall of Fame in 1975. (Courtesy of the C.H. Booth Library.)

Grace Moore and Valentine Parera, c. 1931
Moore (1898–1947), seen here with her husband, Valentine Parera, was an operatic soprano with the Metropolitan Opera in New York and an occasional film star. Coming to Newtown in 1937, she settled in an old Colonial house on Bradley Lane, which she called Faraway Meadows, and rebuilt it, almost doubling its size. In 1947, she embarked on a tour of Europe and died in a plane crash while taking off from Copenhagen Airport. (Courtesy of Elin Hayes.)

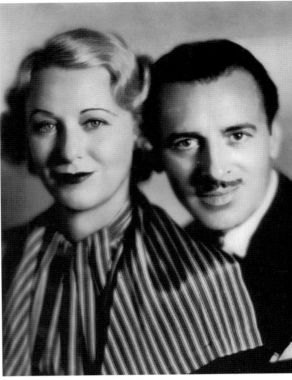

Grace Moore and Friends, 1940
Moore sang only once in Newtown, during the dedication of the Soldier's and Sailor's Monument in 1939, but she was a prominent part of musical activities in town. Here, Moore (second from left) poses with Attolfo Precia (left), master at her singing school; Dorothy Kirston, protégé of Moore's and guest singer at the August 1940 concert; and Mario DiCecco, conductor of the Newtown Orchestra. They are gathered at a fundraising tea before the concert. (Courtesy of *The Newtown Bee*.)

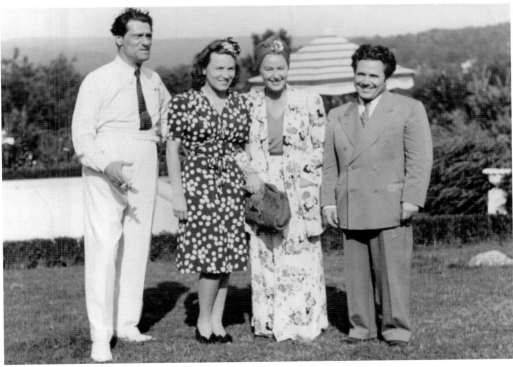

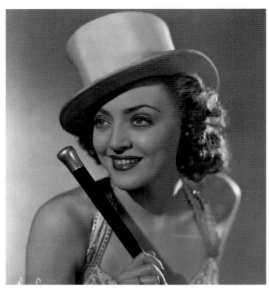

Virginia Lee Lathrop, 1941
Virginia (1915–2009) and
her husband, Mac Lathrop,
were tap dancers on the
vaudeville circuit in the 1930s
and 1940s. In 1952, they
retired from professional
entertainment and founded
the Lathrop School of Dance,
which continues today to
train dancers. Briefly in the
late 1940s, she ran the Village
Coffee Shop (later to become
the White Birch Inn) on the
corner of Queen Street and
Church Hill Road. (Courtesy
of Diane Wardenberg.)

Virginia and Mac
Virginia is seen here
dancing with her
husband. They were
close friends with Ed
Sullivan, appearing
frequently on his
vaudeville shows.
When Sullivan made
the transition to
television, he wanted
them to join him, but
Mac refused, realizing
that once their act
had been seen on
television, they would
have to come up with
new dance routines.
On the vaudeville
circuit, however, they
were playing a different
venue, before different
audiences, each
night. (Courtesy of
Diane Wardenberg.)

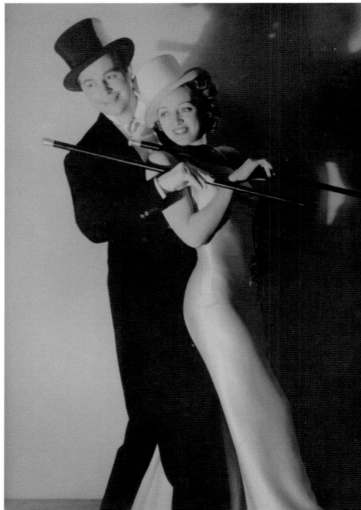

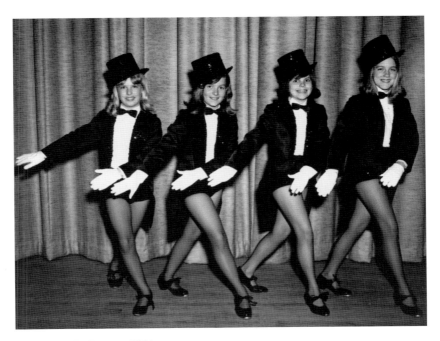

Four Star Babes, c. 1956
This was a group of unusually talented dancers that were used by "Ginny" Lathrop for special performances. The dancer on the right is Diane Wardenburg, who would later become Lathrop's assistant. After Lathrop's death in 2009, "Miss Diane" would become the owner and director. She continues to train a new generation of dancers in the Lathrop tradition. (Courtesy of Diane Wardenberg.)

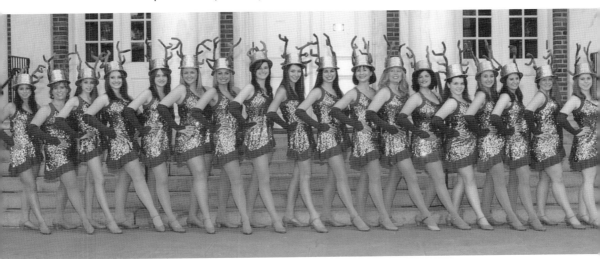

The Stardust Review, 2011
In the spring of each year, it was traditional to hold a great review, showcasing the talent of that year's students. This became known as the Stardust Review, and it has become an anticipated annual event. Here, the main dancers for the 2011 review pose in front of the Edmond Town Hall. They would later perform in the town hall's auditorium. (Courtesy of Diane Wardenberg.)

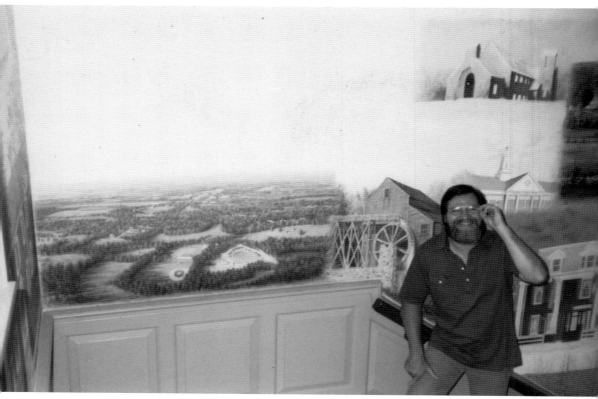

David Merrill, 1983

David Merrill began to paint seriously in the 1960s while earning a living teaching art at Southbury Training School. He turned professional in 1969 and, eight years later, was approached by Southbury town officials to paint a mural in the new town hall. Thus began Merrill's career as a muralist. In 1983, he approached the Edmond Town Hall Board of Managers to paint a mural that would run up the south staircase to the second floor (seen here), across the landing, and down the north staircase. The work includes landmark buildings, some of which are no longer in existence. It was while working on this mural that Merrill met the woman who would become his wife, Beryl Monahan. For a year, she would pass him on her way to work in the tax collector's office.

Louis Untermeyer, c. 1963

Untermeyer (1885–1977) was a nationally known poet, anthologist, critic, and editor who wrote or edited almost 100 books. His compilation of modern American and British poetry became a standard textbook, introducing several generations of young people to poetry. His last years were spent in the Taunton district of Newtown, where he became a founder and supporter of the Newtown Historical Society.

CHAPTER SEVEN

Industry

Newtown always needed small support industries to perform functions, such as grinding grain and sawing timber, that could not be done on the farm, regardless of its self-sufficiency. Every river in town, no matter its size, was utilized for these purposes. Sandy Hook, where waterpower was greatest, also attracted early manufacturing, some of which, like Fabric Fire Hose and Curtis Packaging, remained in business for over a century and a half.

The rubber companies ultimately could not compete with the newer forms of power, such as steam engines and, eventually, electric motors, so they ceased production in Newtown by the late 20th century. A few others, like Curtis Packaging, made the transition and survived, although this was achieved only after changing product lines from horn buttons and combs to the folding paper boxes in which they were shipped. Today, this company flourishes under the guidance of Donald Droppo and his son.

Newtown has been blessed with several innovators who, after perfecting their invention, went on to produce it here in town. William Upham, for example, invented the tea bag during the later years of World War I. He then bought a substantial building in Hawleyville and produced tea bags there until his death 30 years later. Likewise, James Brunot developed the game of Scrabble in Newtown and went on to produce the game in whole and in part from the Queen Street Shopping Center for the next 25 years.

Some individuals, such as Sarah Mannix, were not innovators themselves but aided others in their creative processes. Because of her woodworking skills, Mannix was able to solve the problem of cutting lettered tiles that were of uniform size. This enabled Brunot to produce his deluxe wooden Scrabble sets. She then went on to make wooden toys and run a local greenhouse, becoming a legendary local in her own right.

Although industry did not thrive here as it did in the municipal centers of Danbury and Bridgeport, it did begin here with brilliant innovation from men and woman who are truly legendary locals.

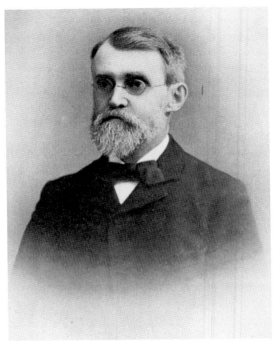

Daniel G. Beers, c. 1905
Beers (1841–1913) began his career as a mapmaker right out of the Newtown Academy. He was one of the students who followed headmaster Homer French into the field to learn surveying and mapmaking (see page 32). Beers became a nationally recognized mapmaker but retired to a farm on Mile Hill in 1880 where he farmed and pursued his passion for inventing. He briefly came out of retirement to draw the town map for Newtown's 1905 bicentennial celebration.

THE EUREKA FOLDING CANOPY TOP,
MADE IN DIFFERENT SIZES, EACH BEING ADJUSTABLE.
Can be attached to nearly all Sizes and Styles of Wagons.
Is easily Removed and Folds like an Umbrella.

Manufactured by D. G. BEERS & CO.,
SANDY HOOK, Conn.

Davis & Barnum
Cassville
N.Y.

Folding Buggy Top, 1905
This business envelope of Daniel Beers shows the type of buggy tops that he manufactured in Sandy Hook in the late 19th century. This top, described as a "folding top," collapsed onto itself like an umbrella, turning the carriage into a convertible. This idea would be repeated with the automobile in the early 20th century.

Samuel Curtis, c. 1890

After apprenticing with the innovative button-maker William Platt in the southern section of town, Samuel Curtis (1818–1899) employed these latest methods and began a button and comb shop in 1845, at the site that is now the current location of Curtis Packaging. Utilizing the horn and bone— waste products of the butchering process on Newtown's abundant farms—Curtis produced buttons and decorative combs used for women's hair until the last decade of the 19th century.

Curtis Buttons and Combs

These buttons and combs, made in the Curtis and Son shops, are kept in a frame in the foyer of the modern Curtis Packaging plant as a reminder of the company's origins. With the decline of animal husbandry in the late 19th century, the company turned to the meat processors of Chicago, shipping boxcars of horn and bone back to Newtown.

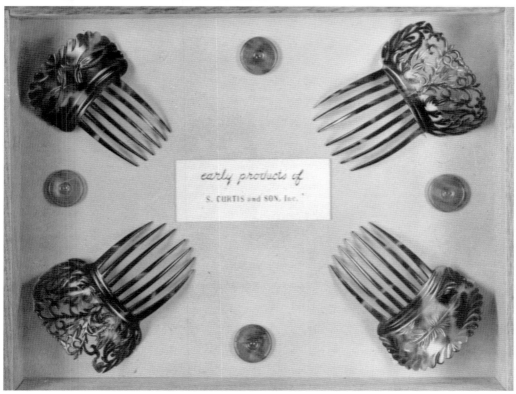

early products of

S. CURTIS and SON, Inc.

Donald Droppo Sr. and Jr., 2012

Button and comb production continued until the depression of 1893, when a combination of poor economic conditions, a change in women's hair fashions, and the development of plastics led to the decision to change product lines. Now, the folding paper boxes that Curtis and Son had produced to package their products became a cash product in its own right, and the factory began to produce paper boxes for other manufacturers.

Curtis and Son continued in the same family until 1980, when Nelson Curtis, Samuel's great-grandson, retired. Under Nelson's guidance, the company had introduced new machine technologies and even experimented with the use of plastic and cardboard packaging. With these changes and the general expansion, the company became Curtiscorp in 1977. With Nelson's retirement, the company was purchased by a partnership of five of its employees, and the name was changed to the familiar Curtis Packaging of today.

This partnership continued to guide the company's fortunes until 1989, when Donald R. Droppo bought most of the company's assets and became the controlling partner. Under his guidance, the company became completely computerized within three years and, by the time of its 150th anniversary in 1995, had purchased the latest printing technology, allowing it to substantially increase its output. This innovation has continued, and larger state-of-the-art presses are positioned to join the leading edge of the packaging industry. Donald Droppo's son Donald Jr. (right) took up the reins in 2012 to guide Curtis Packaging deep into the 21st century.

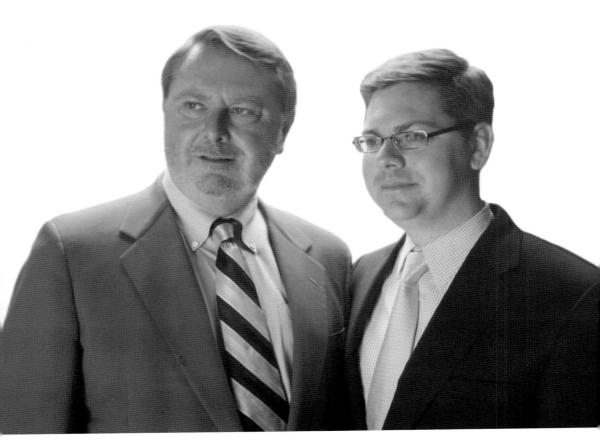

Beach Camp, c. 1875
In 1830, Beach Camp (1805–1885) married Catherine Foote and began manufacturing horn combs in a little shop in Hawleyville. His was typical of the many small button and comb shops, employing one or two workers, that engaged in hand manufacturing. All of these shops died out within a few years, being unable to compete with the machine technologies used by companies such as S. Curtis and Son. Camp's children intermarried with members of the Johnson family, creating a super family that dominated Newtown's cultural life well into the 20th century.

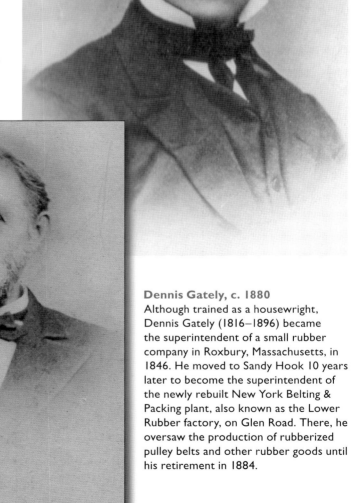

Dennis Gately, c. 1880
Although trained as a housewright, Dennis Gately (1816–1896) became the superintendent of a small rubber company in Roxbury, Massachusetts, in 1846. He moved to Sandy Hook 10 years later to become the superintendent of the newly rebuilt New York Belting & Packing plant, also known as the Lower Rubber factory, on Glen Road. There, he oversaw the production of rubberized pulley belts and other rubber goods until his retirement in 1884.

William Cole, c. 1920

Beginning in banking and silk manufacturing, William Cole (1861–1943) became the president of the Fabric Fire Hose Company of Warwick, New York, in 1890. In 1901, the New York Belting & Packing Company consolidated its rubber-making in New Jersey, leaving Sandy Hook without its major employer. Cole became a local hero when he bought the old rubber factory, converted it, and moved the Fabric Fire Hose operation to Sandy Hook.

The Cole House, 1908

His success in Sandy Hook led Cole to build this mansion in 1908. The house, on Castle Hill Road, overlooks Newtown center. Cole then became involved in town affairs, serving as a trustee of the Newtown Savings Bank and a representative in the state legislature, where he served on the banking committee. At his death, he owned substantial real estate on Castle Hill, including the Castle itself.

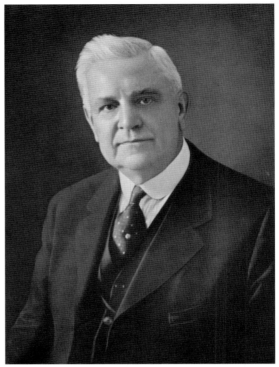

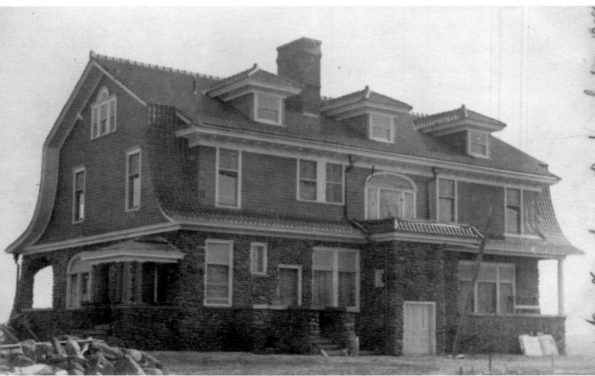

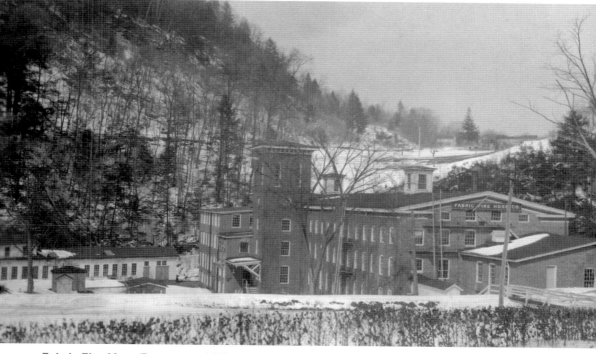

Fabric Fire Hose Factory, c. 1920

This brick factory was built in 1856, replacing a wooden building in which the manufacturing of rubberized cloth began under the patents of Charles Goodyear. Contrary to popular local folklore, Goodyear did not invent vulcanized rubber. His niece lived here, however, and so he was a frequent visitor.

The earlier structure, which was destroyed by fire in 1856, is reputed to have the largest water wheel in the world, measuring 50 feet in diameter. That wheel was saved during the fire by being turned on and thus keeping it constantly wet. Although the wheel is no longer in existence, the large pit in which it once rotated can still be seen in the present building's lower basement.

Shortly before that fire, the plant had been purchased by the New York Belting & Packing Company, which continued to make rubberized conveyor belts and other rubberized items until 1900. The company was succeeded by Cole's Fabric Fire Hose Company, which continued after Cole's death under the aegis of the United States Rubber Company. It, in turn, produced fire hose until 1977, when it moved to North Carolina and rubber manufacturing in Newtown ceased. Since then, the building has been adaptively restored into suites of business offices. The water turbines that served to power the machines of the fire hose company are still run today by Richard Fattibene to supply hydroelectric power to the grid.

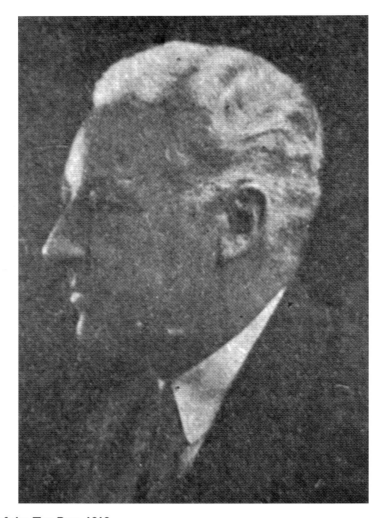

Invention of the Tea Bag, 1919

William Abel Upham (1880–1949) is one of a number of nationally known innovators who lived in Newtown and developed an industry here in the 20th century. He was the son of the US Tea Commissioner under Presidents Cleveland and McKinley, so it was natural that the younger Upham become involved in manufacturing and packaging processed foods. He formed Upham Food Products in New York in 1909 and became one of the town's earliest commuters, going by train every day from northern Newtown to New York.

One morning in 1916, while waiting for his train in Hawleyville, he noticed a vacant building across the tracks from the station and immediately conceived of its possibilities as a food-processing plant. Purchasing it a few days later, Upham began producing peanut butter, among other food items, which he conveniently shipped out on the adjoining railroad tracks.

With US entry into World War I, peanut oil, which was essential for the production of peanut butter, was in short supply. Upham began casting about for an alternative food product. According to legend, Upham had seen a waiter in an exclusive restaurant in New York prepare coffee with a premeasured bag of ground coffee. His experience with tea then led him to experiment with gauze bags of premeasured tea, which he called "Tea Balls." Unhappy with the cloth taste left by the gauze, Upham worked with Johnson & Johnson to develop a tasteless filter paper, and in 1919, the tea bag was born.

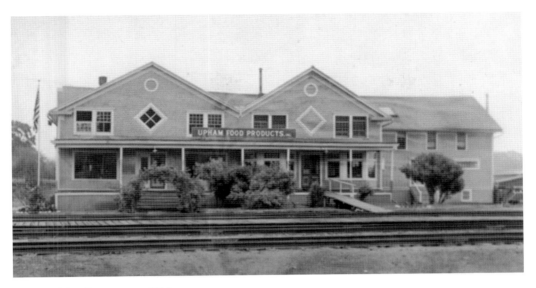

Upham Tea Factory, c. 1919

This building had been constructed by A.G. Baker in 1892 as a showroom for his furniture. Setting up a small comfortable waiting room across from the Hawleyville train station, he lured commuters in to view the furniture, which he could then easily ship by rail to the customer's home in any location in the country. This was the building that attracted William Upham's attention in 1916 and led to the development of the tea bag.

Tea Factory Employees, 1923

This rare photograph of the tea factory's employees, posing by the side of the factory building, shows that the majority of them were women. Since many of them worked out of their homes on a piecework basis, they would have rarely gathered in one place. It is illegal now, but such working arrangements allowed housewives to earn a small income while watching young children.

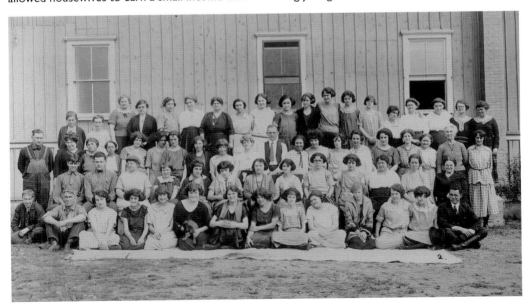

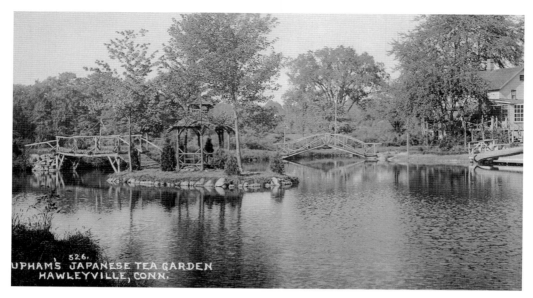

Upham Tea Garden, c. 1930

William Upham became very involved in Hawleyville, establishing the local fire department, instituting road improvements, introducing electricity, and establishing a chamber of commerce, with which he remained very active throughout the rest of his life. He also built a teahouse (right) and adjoining rustic garden. This building was as much a venue to display his opulent collection of Japanese antiques as a place for refreshment.

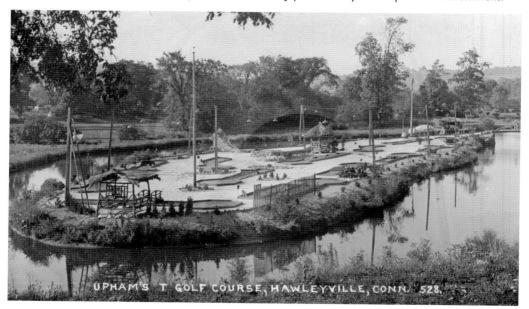

Miniature Golf, c. 1930 (OPPOSITE PAGE)

William Upham's passion for miniature golf led him to construct one of the largest courses in the state, on an island in the middle of the tea garden lake. The inability to play during the winter led him to build a large indoor course a few years later. The indoor course was also a restaurant. The course was surrounded by a gallery, allowing diners to look down on games in progress.

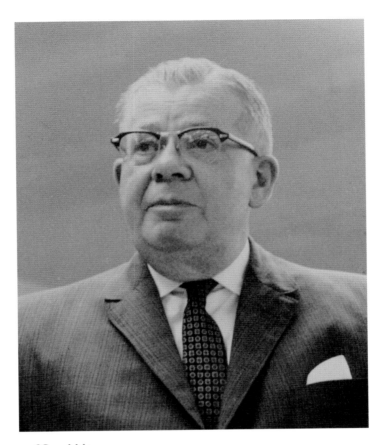

The Developer of Scrabble

James Brunot (1902–1984) did not invent Scrabble, but he did develop it after buying the rights to Criss Cross Words from Arthur Butts. Brunot and his wife had spent many hours playing this game and were determined that it had commercial value, even though Butts had previously failed to interest the Parker Brothers company in producing it. Brunot came up with the name "Scrabble" and entirely revised the rules, simplifying them so that they could be printed on the inside of the box cover. He also added the 50-point bonus for clearing the rack of tiles in a single turn. By 1948, after overcoming some production problems with the help of Sarah Mannix (see page 77), Brunot began manufacturing and marketing the game himself.

For the first four years, the game was a moderate success, benefiting mostly from word of mouth. The break came in 1952, when Robert Strauss, the manager of Macy's department store in New York, happened to play the game while at a house party on Long Island. When he returned to work the next Monday, he approached the head of the game department and asked him to order it. Panic ensued. They had been approached by Brunot the year before, but they thought the game would not sell, so they declined to order it and had lost the literature Brunot had given them. Fortunately, one employee remembered the name of a store in Chicago that Brunot had mentioned as carrying the game, and a phone call saved the department head from Strauss's ire.

The Christmas of 1952 saw an entire counter in the game department devoted to Scrabble, and the popular pictorial magazines *Life* and *Look* each featured illustrated articles on it. The success of the game was insured. For the next 25 years, Brunot continued to handle the business affairs of the company and even the requests for replacement tiles from his office in the Queen Street Shopping Center. (Courtesy of *The Newtown Bee*.)

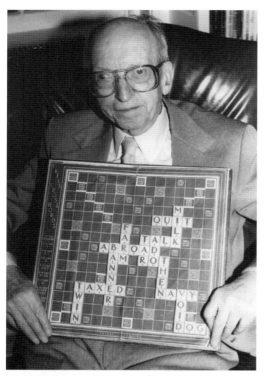

Arthur Butts, 1993
During a visit to *The Newtown Bee* in 1993, this photograph of Butts was taken as he held Criss Cross Words, the game that he invented in 1938 and that would become Scrabble. This photograph was used as his obituary portrait later that year. (Courtesy of *The Newtown Bee*.)

The Game of Troque
Flush with the success of Scrabble, in 1955, James Brunot bought the development rights to a game called Troque (rhymes with "broke") from Arpad Rosti of Brewster, New York. The game, referred to as "castle checkers," consisted of four three-part pieces per player that had to be advanced to the opposite rank of the board before any of the other opponents did so. Although it continued to be produced into the early 1960s, it was never a success.

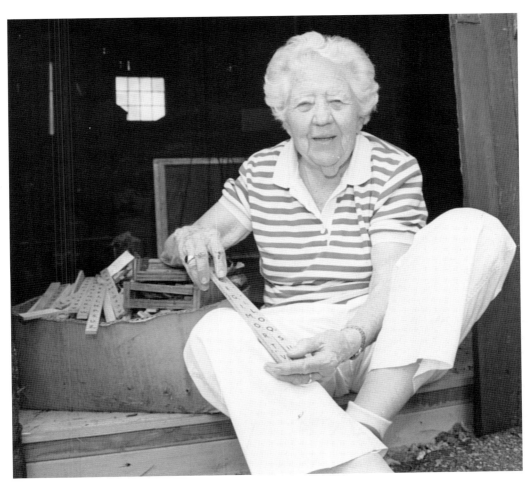

Sarah Mannix, c. 2000

When James Brunot ran into problems with making wooden letter tiles for the early Scrabble games, he turned to Sarah Mannix (1899–2000), who had considerable woodworking skills and her own workshop. The problem was that the tiles had to be uniformly square, but the letters that were silk-screened onto them were not of uniform width. In addition, the width of the saw blade used to cut the tiles apart further complicated the problem. Mannix managed to master the difficulties in her workshop and helped set up the production of the game in the old Flat Swamp District schoolhouse, which until recently stood on Route 302 next to Rock Ridge Country Club.

Mannix was also responsible for cutting into sections the wooden molding to be used as racks to hold the tiles. The quality of this molding in the post–World War years was variable, so there was a good deal of short waste sections that could not be included in the game box. So that they did not go to waste, she pieced them together along the ceilings of her house when she and he husband were remodeling, creating an elegant if fragmented crown molding.

Mannix was a major figure in town outside of her work on Scrabble. She had been educated in the local district one-room school and in turn taught in one of those schools. She also ran a kindergarten after she was married, resulting in her being barred from working in the public schools. She was active in town politics, which is where she met James Brunot. In her later years, Mannix ran a successful greenhouse and flower business in the back of her home on South Main Street. She was a local legend in her own right. Ironically, she never played Scrabble. (Courtesy of *The Newtown Bee*.)

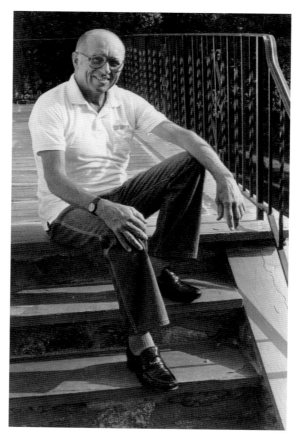

The Father of Robotics

Like James Brunot with Scrabble, Joseph Engelberger did not invent the robot, but he did develop it into a viable and efficient tool of production. In the early 1950s, George Devol, from Greenwich, had developed and patented a machine he called a "programmable article transfer" that would take hot castings safely from one location to another and put them into proper position for assembly. Devol met Engelberger at a cocktail party in Fairfield in 1956 and Engelberger, an engineer who had always enjoyed science fiction, saw the machine's potential in assembly plants like that of General Motors. By 1962, he founded Unimation, the first company devoted to producing robots.

The concept of using robots on production lines was slow to catch on here, but in 1967, Engelberger was invited to Japan. That nation's business leaders quickly realized its potential for revitalizing their industry. A year later, a licensing agreement was signed between Unimation and Kawasaki Heavy Industries. From this, the use of robots has grown so that they appear in almost all manufacturing. It is mistakenly assumed that the Japanese were the inventors of robotics.

Engelberger, seen here in 1984, sold Unimation to Westinghouse in 1983 but has continued working in the field, turning his attention to developing robots called "Helpmates" that can aid the elderly, enabling them to remain in their homes rather than having to be moved to an assisted living facility.

Over the course of the past half-century, Engelberger has won numerous honors for his work, including an honorary doctorate from Carnegie Mellon University and the Leonardo da Vinci Award from the American Society of Engineers. His greatest honor came in 1997, when he won the Japan Prize, the Pacific equivalent of the Nobel Prize, which was conferred on him by the Emperor of Japan. Probably most fitting was his designation by the magazine *The Connoisseur* as one of "America's Living Monuments." (Courtesy of *The Newtown Bee*.)

CHAPTER EIGHT

Retail

Industry is only half of the story of Newtown's economy. The other half consisted of retail firms that served citizens directly by distributing goods and supplying services. A good example of the retail aspect of the town's economy was its hotel business.

During the later part of the 19th century, the town's bucolic atmosphere made it an ideal resort location. Here was a place to escape the rigors of urban living for a week or two. Two hotels on Main Street dominated this trade: the Newtown Inn and the Grand Central Hotel, known more recently as the Yankee Drover. They were run by William Leonard and Michael Houlihan, respectively. Both of these men became legendary locals, being well known in the community and serving in numerous volunteer positions in town.

An even more important part of retail business was the succession of general stores and the men who made substantial incomes managing them. Small stores supplying anything that could not be grown or made on the town's small farms date back to the 1780s. As the Industrial Revolution matured, however, goods became available that were more inexpensive and were often better made than those produced on the farm. The storeowners of the late 19th and early 20th centuries were perspicacious enough to expand their businesses to include this abundance of machine-made goods.

As these entrepreneurs rose in social stature, they grew financially. They served on numerous town offices, boards, and commissions, making their business acumen available to the town. They also provided volunteer services that the town's people otherwise could not afford. It is no surprise, for example, that for the first 50 years of its existence, the officers of the Newtown Savings Bank accepted no salaries for their services. Many businessmen were also members of the Men's Literary and Social Club of Newtown Street (see page 122), taking on projects such as the town's bicentennial celebration (see page 11) and replacing the flagpole in the middle of Main Street after it had been damaged by lightning.

Retail entrepreneurship extends beyond trade in merchandise, and several local legends supplied other services. Louis Lorenzo turned a local snack stand into a restaurant that is a legend in itself and that continues to serve the Riverside population and visitors to town.

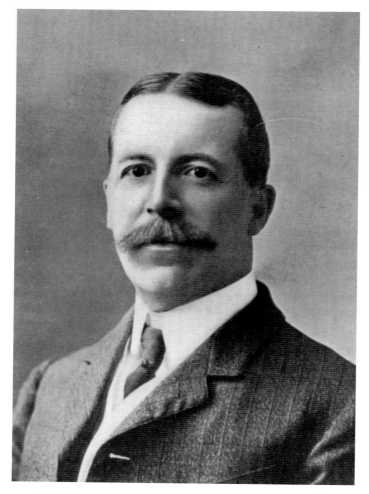

William A. Leonard, 1890

It is not well known today, but the village of Newtown in the late 19th and early 20th centuries was a resort location. City dwellers would take the train to the Newtown depot on Church Hill Road and there be met by stagecoaches that would take them to one of several hotels on Newtown Street (now Main Street). One of the largest of these was the Newtown Inn, located where the Cyrenius H. Booth Library is today. The Newtown Inn was run by William A. Leonard (1861–1918).

After Leonard's father died young, his mother took over what became known as the Leonard House in Springfield, and it was growing up there that became his education in the hotel business. Leonard became a hosteller in his own right in the spring of 1887 when he bought out Dick's Hotel, a very successful Newtown inn with roots preceding the Civil War. He continued this success until a disastrous fire in 1897 entirely destroyed the old building. With insurance money, Leonard built a larger structure, capable of handling 100 guests, under the new name of The Newtown Inn.

Realizing the value of insurance, he began a parallel career as an insurance agent, building this business into one of the largest agencies in the area. Leonard also became deeply involved in Republican politics. At that time, the town was predominantly Democratic, so, although he was nominated for almost every town office, he only served as borough treasurer, a post he held until his death. He was also a member of the Men's Club and, by virtue of that, he was a member of the town's bicentennial committee.

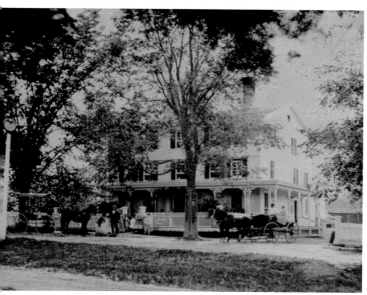

Original Newtown Inn, c. 1870
Although this house dates to 1790, it was purchased by Sallu Pell Barnum in 1843 and rebuilt as a two-story hotel named for its new owner. In 1861, the building was purchased by William Dick, who added a third floor and built the business into one of the premier country summer hotels in Connecticut. William Leonard then purchased the building in 1887 and operated it until it was destroyed by fire in 1897.

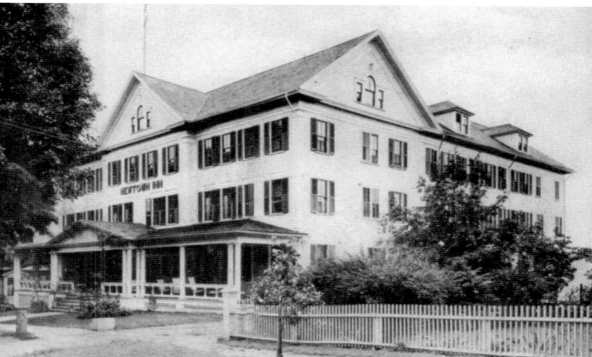

Rebuilt Newtown Inn, c. 1910
Leonard immediately rebuilt the hotel into the immense structure shown here. After Leonard's retirement in 1911, the business fell into a slow decline until it was abandoned in 1922. Purchased by Mary Hawley in 1925, the structure became the site of the new library, which was posthumously built by her estate. This building was sawn into sections and many of its parts were moved down the street to become outbuildings in back of several residences.

Michael J. Houlihan, c. 1890

A second-generation Irish American, Michael Houlihan (1898–1925) began in the hotel business in 1874, working as a porter and general utility boy. By 1887, he had become the proprietor of the Grand Central Hotel (located where the Dana Holcomb house is today). He also became deeply involved in Democratic politics in town and, unlike Leonard, served as town clerk for 10 years, as registrar of voters, and as a representative to the state assembly and senate.

Grand Central Inn, c. 1900

This building, originally the house of John Chandler, was constructed before the Revolution. It was here that William Edmond (see page 12) received his training as a lawyer. In 1870, it was enlarged and turned into the hotel where Michael Houlihan served his hotel apprenticeship. After he retired in 1925, it became the Parker House and, after World War II, the Yankee Drover. It was destroyed by fire in 1981.

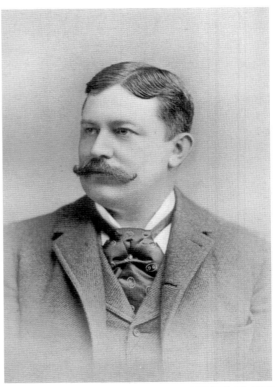

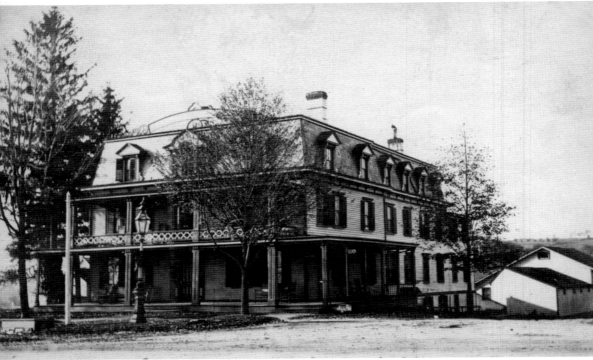

Robert H. Beers, c. 1890

Beers (1866–1922) was the son of George Beers, a successful cattleman and farmer on Palestine Road (see page 22). Rather than farming, the younger Beers turned to retail trade, apprenticing under Edgar F. Hawley in his Main Street store (where Flag Pole Realty is today). Beers eventually took over the store and ran it successfully until his death. He was one of the last charter members of the Men's Club and of the executive committee for Newtown's bicentennial celebration (see page 11).

R.H. Beers Store, c. 1915

A small general store has stood on this spot since the mid-1780s. The original store still stands immediately behind this building facing West Street. The building as it appears in this postcard was rebuilt in 1870, during which the store (on the left of this business block) was expanded to what it is today. After Beers's death in 1922, it became an A&P, Newtown's first chain grocery store. It ceased to be a store in 1962, when the A&P moved to the Queen Street Shopping Center.

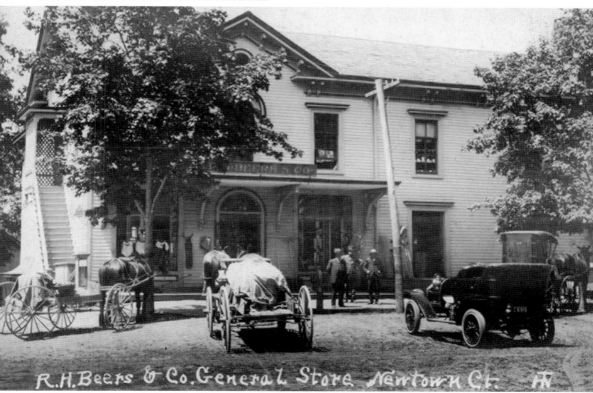

R.H. Beers & Co. General Store Newtown Ct.

H. Hawley Warner, 1991

The last proprietor of Sandy Hook's Red Brick General Store was H. Hawley Warner (1914–1999). There has been a member of the Warner family associated with this store since 1861, when William B. Glover took James H. Warner into partnership with him. Glover was a major financier in Sandy Hook, having been associated with the rubber factories and numerous other businesses. He established the first retail store on this site in 1833 and retired from it three years after taking on Warner as a partner.

Almost 100 years later, H. Hawley Warner and his brother J. Hobart Warner became partners in the business, taking over from their father in 1944. At this time, general stores were beginning to die out as they came into competition with chain grocery stores such as A&P. The diversity of products that the Red Brick Store carried, along with the willingness of the Warners to pool their merchandise purchases with the other independent stores in town, meant that it could marginally hold out against the national chains. The business was also helped by hiring George Clark, son of Homer Clark (see page 25), to set up a meat department, which the chains had not done at first.

Hawley Warner took over as sole proprietor in 1964. For the next decade, the store enjoyed a reputation for carrying almost any obscure item, from a chimney for an old kerosene lamp to an old-fashioned washboard. It might take a few minutes searching for it upstairs, but it was there. That, and the quality of the meats supplied by Clark, insured the store's success until 1978, when Hawley retired. In that year, Newtown lost its last genuine general store. (Courtesy of *The Newtown Bee*.)

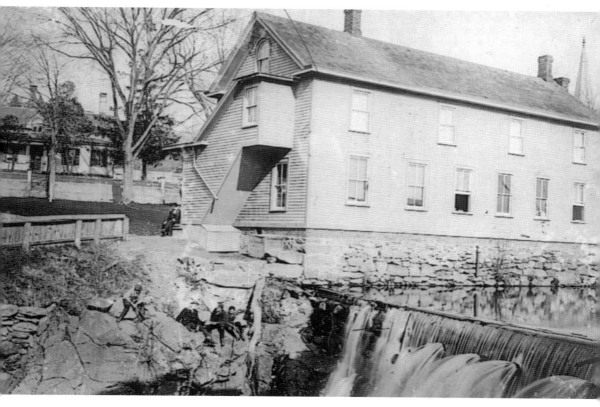

The Original Store, c. 1900
The building shown here is the original wooden store, built by William B. Glover in 1833. It originally stood where the Red Brick Store is today. When it came time to expand the business, this building was moved across Church Hill Road into what is today Washington Park. At the time of this photograph, the old store contained the post office, Sandy Hook Library, and an undertaker's parlor on the ground floor. The second floor was the Masonic Hall. The building burned down in 1905.

The Red Brick Store, 1908
This larger brick building replaced the original store in 1857. This was the building out of which Hawley Warner retired in 1978. Subsequent to that, the building has served a number of different functions, including a video store and a succession of restaurants, most recently, The Foundry Kitchen and Tavern. The building itself has changed very little since this photograph was taken over 100 years ago.

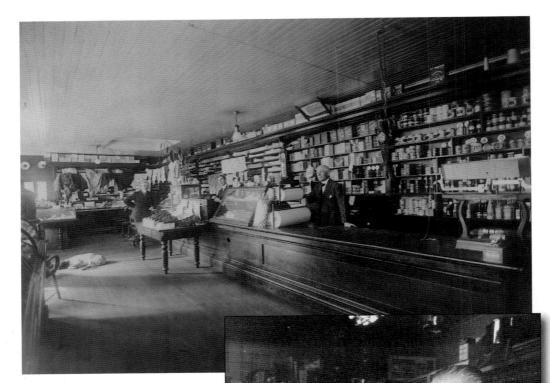

Interior of a General Store, 1918
This photograph was taken on the occasion of Hobart G. Warner (Hawley Warner's father) taking over the store from his partners, George Taylor and Hobart Curtis. Taylor is standing at the far end of the counter. Warner is in the center, behind the counter, and Curtis is on the right, also behind the counter. The dog is Spot.

Faithful Employee
William Hayes began working in the Red Brick Store as a delivery boy at age 13. He retired in 1971 after a career of 68 years. Hayes was also heavily involved in St. Rose of Lima, serving as a trustee, organist, and choir member. He was made an honorary life member of the Virgilus Knights of Columbus. He was as well known as his employer, since, as seen here around 1964, he was the one who most frequently waited on customers. (Courtesy of Jane Sharp.)

"Doc" Crowe Celebrates, 1944

Another important retail business in Sandy Hook was the drugstore run by Ralph Betts and his son at the turn of the 20th century (see page 45). After the elder Betts's death, the business eventually passed on to a partnership of Martin A. Corbett and Arthur "Doc" Crowe (?–1957). They expanded the business, adding a soda fountain and a grocery section in the rear of the store. They retained the apothecary section, with its stock of medicines and drugs, which they continued to dispense in the front.

Doc Crowe first came to Sandy Hook to work in the drugstore in 1904, when it was Betts and Betts. He had graduated from the New York School of Pharmacy three years before and had worked briefly in Torrington and Waterbury before coming to Sandy Hook. This photograph shows Crowe (right) celebrating the 40th anniversary of his coming to town. He is posing with Charles Lockwood, who served as a soda jerk during World War II.

During the war, Crowe, the sole proprietor after the death of Corbett in 1941, wrote letters to countless Newtown men serving in the armed forces. He also solicited the photographs seen behind him. The sailor who appears just below Crowe's left elbow is George Clark Jr., who once worked there as a soda jerk. This photograph comes courtesy of Clark, who obtained it from the files of *The Newtown Bee*.

Levi C. Morris, 1905

The merchant Levi Morris (1858–1942) came from a long line of storekeepers. His uncle, also named Levi C. Morris, in 1864 constructed the building later used by Corbett and Crowe, as a small grocery store. The younger Levi Morris, seen here, was widely known as the proprietor of the general store located just south of the Edmond Town Hall, from 1914 until his death.

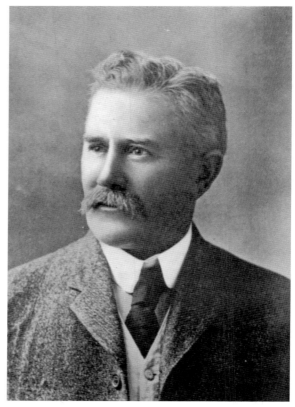

Main Street Fire of 1914

Morris lived at 14 Main Street, in back of which was his original store, his undertaking parlor, and a barn-garage. On April 25, 1914, the cry was heard that his store was on fire. Before it was put out, all of his outbuildings were destroyed. This prompted Morris to accept an offer from Rodney Shepard (1888–1941) to go into partnership in Shepard's general store at 43 Main Street.

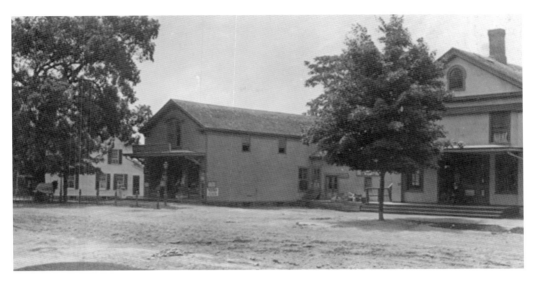

General Store, 1910

This postcard shows the General Store when it was run by Henry Rupf, just before Morris and Shepard went into business there. The partnership continued here for 28 years until the two men died within months of each other, in 1941 and 1942. This store was the first building in Newtown to be wired for electricity when the first electrical feed came to town in 1914, a few months after the formation of the partnership between Morris and Shepard.

General Store Interior c. 1915

This photograph shows the interior and main room of the general store shortly after the partnership was formed. Morris is standing at the left counter, and Shepard is on the right. The two clerks standing in the rear are unidentified. The store continues today as the Newtown General Store, primarily a deli and convenience store.

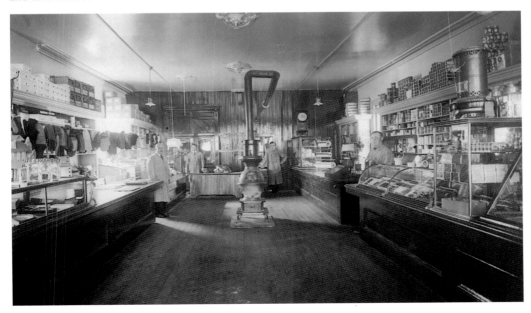

Austin B. Blakeman, c. 1905
In the outlying sections of town, general stores sprang up to serve the small neighborhoods that grew up around the schoolhouses. Austin Blakeman (1858–1915) was the proprietor of one of these stores in Botsford. He was the Botsford postmaster from 1883 until 1910 and was the Botsford stationmaster from 1884 until 1894. For a while in the 1870s, he also taught in the old Middle Gate School.

Botsford General Store, c. 1910
Blakeman's first store was next to the Botsford depot, convenient for his parallel occupations of stationmaster and postmaster. In 1893, he built this combination store and residence a few hundred yards to the north. Blakeman installed the post office there, and it remained at this location until 1964, when the store closed and the post office moved to Route 25. The old store remains but is currently vacant.

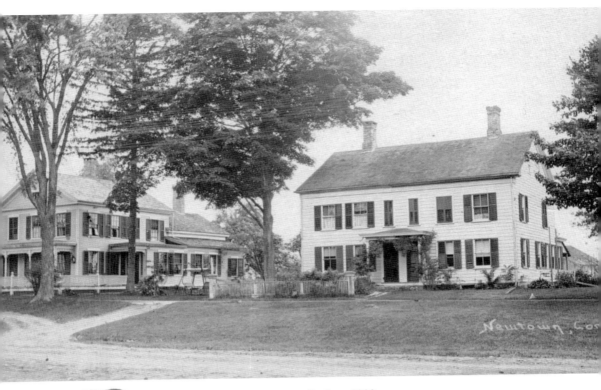

Honan Funeral Home, Before 1910

In 1912, when William Honan Sr. (1882–1966) decided to buy the house seen here on the right as his residence and funeral home, anti-Irish sentiment in town was such that the sale was blocked. He ultimately employed a Yankee friend from Danbury to buy it and then sell it to him. This building has seen three generations of Honans as funeral directors. Daniel Honan, William Sr.'s grandson, currently runs the family business. The house on the left was William Jr.'s residence.

William Honan Jr., c. 2000

William Honan Jr.'s father apprenticed with Levi Morris in the undertaking business, becoming the first undertaker in Newtown to practice embalming. The elder Honan began on his own in 1903, and in 1947, his son joined him. William Jr. (1922–2009) took over the business after his father's death in 1966. He was deeply involved in town politics, becoming a member of the first legislative council in 1975 and serving as its chairman from 1978 until 1982.

Papa Lorenzo, c. 1950

When the Stevenson Dam was finally closed in 1919, Lake Zoar was formed as the waters of the Housatonic River backed up. Those who owned property around this lake were few, but they found that their real estate was now valuable waterfront property. In 1921, Soule-Roberts, a Bridgeport partnership, bought up a sizable parcel of land at the end of Riverside Road and divided it into small lots, which they sold to those wanting to build cottages for summer vacations. This community became known as Riverside and was the beginning of the so-called Vacation Communities that would eventually include Shady Rest, Cedarhurst, and Pootatuck Park. In the late years of the Depression, many residents winterized their cottages and began living in them year-round.

Louis J. Lorenzo (1900–1995) was a second-generation Italian American who was born and brought up in Bridgeport. As a young man, he went into the grocery business in that city with two of his brothers. He became attracted to the Riverside community in 1926 and built the hot dog stand seen on the next page. There, he sold ice cream, frozen candy, and soda, in addition to hot dogs. He then built several cottages around this stand, which he rented to vacationers in the summer. He also rented canoes. (Courtesy of Laurie McCollum.)

Lorenzo's Hot Dog Stand, 1926
From its inception, this stand served the needs of vacationers for light refreshments and for necessities like as ice for coolers. By the early 1930s, Lorenzo obtained a liquor license and enclosed the stand, creating a barroom. In the middle or late 1930s, the back section was added, creating a restaurant. The framing of the original stand can still be seen in the bar section of Lorenzo's today.

Lorenzo's Restaurant, c. 1950
By the end of World War II, the restaurant looked as it does in this early 1960s photograph. In 1946, Lorenzo added pizza ovens, making his restaurant the first to sell pizza in Newtown. Louis Lorenzo formally retired in 1967, selling the business to his son-in-law Paul McCollum. Today, McCollum's daughter Laurie continues the family tradition, now in its third generation.

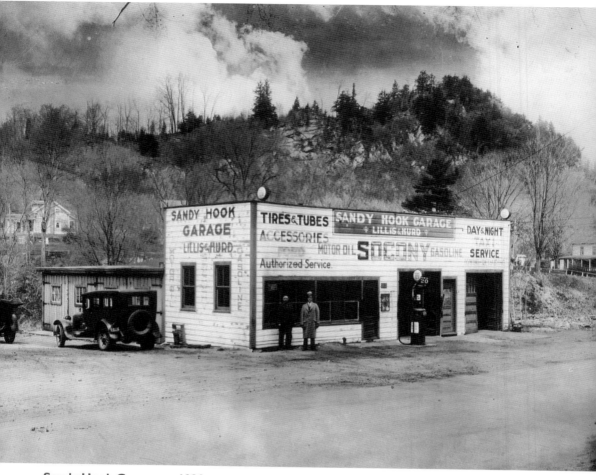

Sandy Hook Garage, c. 1920
As the popularity of the automobile grew in Newtown after 1910, facilities were built to sell and service them. Initially, gas, oil, tires, and other automotive supplies were handled by the town's general stores, but by 1909, William W. Wakelee opened the town's first commercial garage in Sandy Hook. He also was responsible for forming the Newtown Automobile Club and establishing the town's first driving school, all in 1909. Wakelee qualifies as a local legend, but, unfortunately, no portraits of him survive.

By the early 1920s, the number of automobile repair facilities had proliferated, and the partnership of Lillis and Hurd was formed. They ran the Sandy Hook Garage, seen here. It was a dealership for Hudson and Essex cars as well as a repair facility for those models. The partners are shown standing in front of the building, but it is unclear which is Lillis and which is Hurd.

The partnership was relatively short-lived, ending in 1927. Lillis's full name and subsequent history are unknown, but Austin Hurd (1886–1954) continued to be a developer in Sandy Hook. When the Niantic mill was torn down in 1926, Hurd purchased the land on which it had stood, located at the end of Church Hill Road, on the west abutment of the bridge that crosses the Pootatuck River. On this plot, he built a business block. The Sandy Hook Package Store presently does business there. Hurd also continued to run the garage by himself, until he retired in 1952, after which it was eventually taken over by Adolf "Junior" Dreyer. Hurd, barely remembered today, was responsible for the present look of the Sandy Hook business district.

CHAPTER NINE

Sports

Sports have always been important in Newtown. The first examples of organized sports date back to the post–Civil War era, when amateur baseball teams sprang up in different sections of Newtown. They played among themselves and against similar teams in neighboring towns, but very little is known about them or their records. Not until the establishment of *The Newtown Bee* in 1877 did relatively regular coverage of sports activities begin. Amateur baseball teams continued playing and, following World War II, the parks and recreation commission was formed and assumed the task of organizing them.

Newtown High School became the focus for sports activities after it was established in 1902. Within six years of its founding, the school had formed a football team—no small feat considering the era's low male student enrollment. By 1911, however, the low numbers became an obstacle too difficult to overcome and, along with parental complaints about football's roughness, especially without helmets and padding, the game ceased in Newtown until after World War II.

The high school's basketball program fared somewhat better. Newtown may have had the first girls' basketball team in the state. Since the team's establishment, it has played continuously to the present day. The same is true of boys' basketball.

The Sandy Hook Athletic Club (SAC) was formed by Wilton Lackaye (see page 59) and other community leaders, including Paul Smith (see page 50), in 1946. The club supplied opportunities for boys to play basketball and baseball outside of the school system. A clubhouse was located on Riverside Road, and SAC built fields that are still being used by town teams, even after SAC's dissolution in the late 1960s.

When Harold DeGroat and Ann Anderson were hired to reform and revitalize the high school physical education program for both male and female students, a revolution in local physical education, health, and athletic training followed. Their efforts spread to the community, with the formation of an organizational board, the forerunner of the parks and recreational commission. DeGroat even achieved some national recognition for his efforts. By the time DeGroat and Anderson retired, in 1966 and 1973, respectively, the face of sports in Newtown had been permanently transformed.

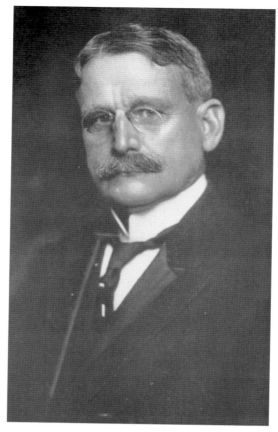

Cornelius Taylor, c. 1920

Once known as one of the most involved men in Newtown, Cornelius Taylor (1850–1935) is almost forgotten today except for his peripheral contribution to town sports. He was born in the Hattertown section of town and became an assistant station manager for the Stepney depot of the Housatonic Railroad when he was 18 years old. Five years later, he moved north to become associated with the station at Newtown and, owing to his considerable telegraphy skills, quickly became stationmaster there. His responsibility extended to the freight yard, and he soon took over the coal, grain, and feed business adjacent to the yard, which had been established by an ailing Jabez Botsford.

Taylor retired from the railroad in 1903 due to ill health, and from the coal and grain business seven years later. After a period of much needed vacation, he returned to devote himself to public service. His affiliations read like a virtual directory of Newtown organizations at the turn of the 20th century.

One of Taylor's most important contributions was his service as a trustee for the Newtown Agricultural Fair. This organization, begun in 1895, became as large as the one in Danbury before it ran into financial difficulties 10 years later. The fair was held on the large parcel of ground on which the Hawley School now stands; its quarter-mile racetrack extended for several acres to the rear. Since he was a principle stockholder, Taylor obtained all of this real estate during the dissolution of the fair's assets. He sold the front portion of the property to the town for the Hawley School in 1920. A short time later, he donated the back acres to the town for sports fields, which to this day are known as Taylor Field. Taylor's donation came with two stipulations: first, that there would be no sports contests played on the fields on Sunday; and second, that the fields would only be used for nonschool athletic events if "there was a majority vote of all pupils registered of the said [Hawley] school at any time." Thus, the town came into possession of its first major athletic facility.

Girls' Basketball, 1912

The first organized sport for girls in Newtown appears to have been basketball. An article in *The Newtown Bee* announces that, before a home football game with New Milford in 1910, there was to be a basketball game against the New Milford girls played on an outdoor court. There is no record of who won, but at least one authority claims that this was the first girls' basketball game played in Connecticut.

This photograph shows the first regular team formed, the 1912 season. The bloomers were the typical uniform for this period. As only five girls are shown, with no substitutes, they appear to have played under the original five-player team rules. This would have meant they did not dribble the ball, but only advanced it by passing it forward or tossing it in the air and running forward to catch it in a kind of reverse dribble.

The girls shown here, and their positions, are identified as, from left to right, Sarah Beers (right forward), Ina Driscoll (left forward), Jessie Beers (captain and center), Mildred Christopher (right guard), and Anna Greenblatt (left guard). The girls were probably high-school juniors when this photograph was taken, as the same photograph was used in the next yearbook, for 1913. This is the only sport that has been played continuously at Newtown High School to the present day.

The Last Football Team, 1911

This photograph is enigmatically inscribed "The Last Football Team." Since there had been teams in the period following World War II, the reason for this claim remains obscure. Research in Newtown High School yearbooks revealed that a football team had been part of the school's athletic program since 1908. The 1912 yearbook gives the 1911 season's record: the team played six games, all but one of which was either a loss or a tie. Only the last game, against Shelton High School, resulted in a win. The athletics section of the 1913 yearbook claimed that there had been an attempt to form a team, but that "they lacked the weight." Presumably, the school did not have enough boys inclined to play, and those who were so inclined lacked the necessary size.

The 1914 yearbook notes another attempt to form a team, but the same problem was encountered. In addition, a more cogent reason was mentioned: there were parental objections that the game was too rough, especially without upper body protection, as evidenced in this photograph of the "last team." The effort to form a team mentioned in the 1914 yearbook was the last until Harold DeGroat formed a modern, well-padded team just after World War II.

Regrettably, the identities of the members of the team shown here were not recorded. They are arranged in fighting formation in front of the old high school, which burned down in 1920.

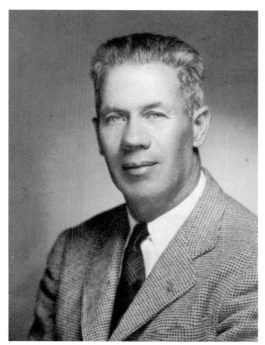

Harold DeGroat, 1945

In 1944, Harold DeGroat graduated from Springfield College and in the fall of that year was hired by Newtown High School to reform and revitalize the school's physical education and athletic program. Two years later, in 1946, he became the director of the town's newly formed health and recreation commission, which would later become the parks and recreation commission. In that capacity, DeGroat developed a health and fitness program for adults. In the mid-1960s, "Coach" DeGroat achieved national recognition for his featured article in *Sports Illustrated* on the necessity of physical education in America's towns. By the time he fully retired in 1966, he had entirely created or reorganized the structures of Newtown sports and athletics. His status as a legendary local was insured when the high school stadium was renamed in honor of him and Ann Anderson (see page 100).

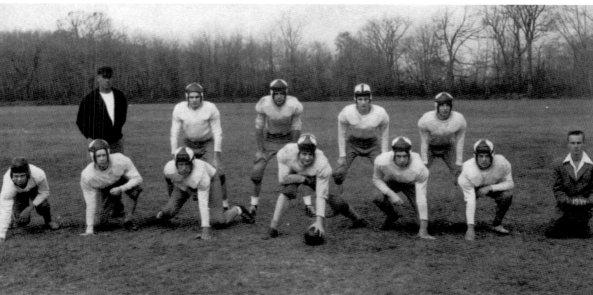

The Reintroduction of Football, 1944

One of the first changes that DeGroat introduced to the high school was the formation of a six-man football team. This type of football had been developed in 1934 as a way for high schools with low enrollments to field a team. It consisted of six men on each side, with at least three men on the line of scrimmage, and was played on a gridiron of only 80 yards. This version of the game set 15 yards for first downs, insuring frequent possession changes. All players were eligible receivers. When high school enrollments rose in the late 1950s, the football program adopted the standard 11-man squad.

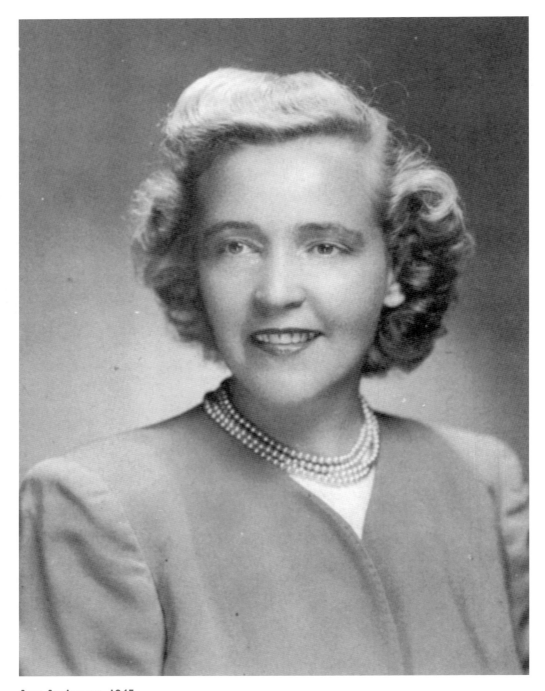

Ann Anderson, 1945
Arriving at Newtown High School in the same year as DeGroat, Ann Anderson did for girls' athletics what he did for the boys, and at a time before Title IX applied legislative pressure to expand athletic programs for girls. Anderson also partnered with DeGroat to bring women's athletics to town so that physical and health training could continue after graduation from high school. She retired in 1973.

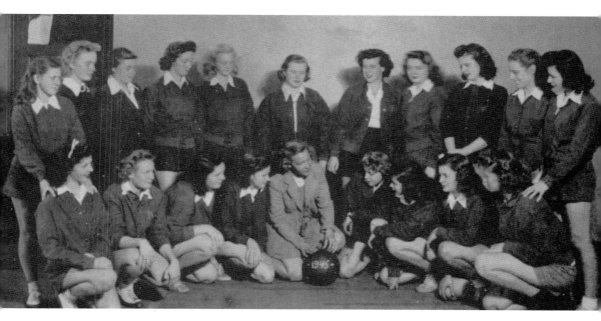

Revitalization of Girls' Basketball, 1945
One of Anderson's first tasks was to revitalize the girls' basketball team. Her success can be seen in this photograph of the first team, with Anderson kneeling at center. The number of team members was at an all time-high. Within six months, Anderson's team had won the championship of the southern division of the Housatonic Valley League and missed winning the full Valley championship by a narrow margin. The next year, the team won the league championship, repeating that feat in the subsequent three years.

Art Spector, c. 1950

The only professional athlete to have called Newtown his home was Arthur Spector (1918–1987). After graduating from Villanova, where he distinguished himself as a forward, he played professionally for the Baltimore Bullets and the Trenton Tigers before being signed by the Boston Celtics in 1946. He played four seasons with the team before retiring in 1950. Spector played in 160 career games and scored a total of 852 points. (Courtesy of *The Newtown Bee*.)

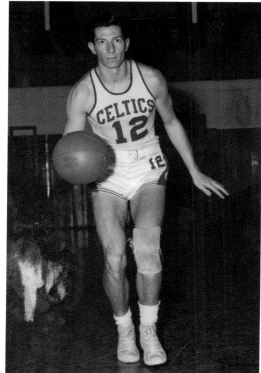

Planning and Zoning, c. 1978

Art Spector came to Newtown in 1957 and immediately became involved in town affairs. He is best known for serving on the planning and zoning commission, which had been formed the year he arrived. In this capacity, he was responsible for the controlled growth of the town in the 1960s, 1970s, and 1980s, the decades with the greatest residential growth. Spector is legendary for shaping Newtown's postwar landscape. (Courtesy of *The Newtown Bee*.)

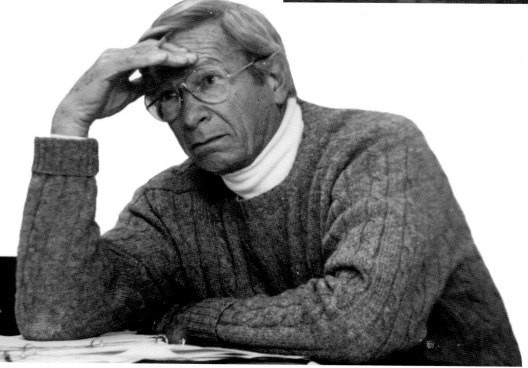

The Sandy Hook Giants, c. 1930

This team photograph shows the Sandy Hook Giants sometime between 1928 and 1931. This amateur team, part of the Western Connecticut League, played similar teams from Redding, Wilton, Southbury, Woodbury, Georgetown, and Bridgeport. The Giants' home field was at Pine Grove Park on Washington Avenue, under what is today Route 84. George Clark Sr., who worked in the Warner Store's meat market, was the manager. His son George Jr. was the batboy and water boy.

Shown here, as identified by George Clark Jr., are, from left to right, George Clark Jr. (kneeling in front); (first row) Jack Price, pitcher; Cliff Beardsley, third base; Walt Nichols, position unknown; Bill Kelly, left field; George Conger, catcher; and Wilbur Griscom, center field; (second row) Frank Hopkins, shortstop;, Frank Hubbell, first base; Fred Kuhn, pitcher; Joe Walker, right field and catcher; Hobart Warner, shortstop; George Clark Sr., second base and manager; and Donald Griscom, scorekeeper. (Courtesy of George Clark Jr.)

Sandy Hook Boys Athletic Club, 1947

SAC was formed in 1947 to give boys in Newtown a chance to learn to play baseball and basketball at a time when athletic facilities were scarce and an organization to supervise these sports was nonexistent. Under the inspiration of Wilton Lackaye and several other town leaders, SAC managed to acquire property off of Riverside Road for fields and a clubhouse.

This photograph shows the first annual banquet, held on Thanksgiving Day in 1947 at the Parker House (subsequently the Yankee Drover.) Edith Parker, the proprietor, was a strong supporter of SAC, becoming its senior vice president. Wilton Lackaye is standing in the back, framed by the window. Regrettably, the boys are not identified.

The organization continued until the late 1960s, then faded away as other organizations in town, such as the schools and the parks and recreation department, met the boys' athletic needs. The SAC fields are still being used by the town's sports teams, especially the soccer program.

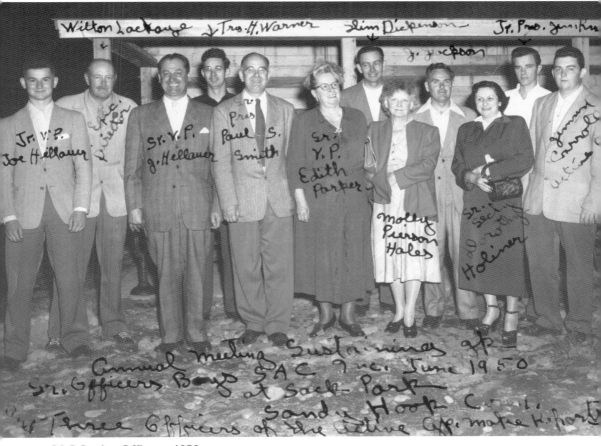

Handwriting on photograph:
Wilton Lackaye — J. Tro. H. Warner — Slim Dickenson — Jr. Pres. Jim Kn—
J. Jackson
Jr. V. P. Joe Hillauer — Exec. Director — Sr. V. P. J. Hillauer — Sr. Pres. Paul S. Smith — Sr. V. P. Edith Parker — Molly Pierson Hales — Sr. Sec. Holiner — Jimmy Carroll Active
Annual meeting Sustaining qk
Sr. Officers Boys SAC Inc. June 1950
at Sack Park
Sandy Hook Conn.
Three Officers of the active qk. make report

SAC Senior Officers, 1950

The early officers of SAC were a virtual who's who of Newtown leaders. This photograph was taken in front of the unfinished clubhouse in June 1950. The officers are all identified, unfortunately by the handwriting on the photograph. Shown here are, from left to right, Joe Hillauer Jr. (vice president), Wilton Lackaye (founder and executive director; see page 59), Joe Hillauer Sr. (vice president), Hawley Warner (treasurer; see page 84), Paul Smith (senior president and publisher of *The Newtown Bee*; see page 50), Edith Parker (senior vice president, proprietor of the Parker House; see page 104), Slim Dickenson (Newtown first selectman), Molly Pierson Hales, Jerome Jackson, Dorothy Holiner (senior secretary), Jim Knapp (junior president), and Glenwood Carroll. The three junior officers (Hillauer, Knapp, and Carroll) were older boys in the club, elected to be active officers who made reports to the senior officers.

Preparing the Fields, 1951
The boys were expected to help maintain the fields. Here, they take a break from working on the lower field. The boys are preparing a softball diamond and a football field for seeding in the fall of 1951. The dog was the club mascot, Peanuts. The boys are not individually identified.

Finished Baseball Field, 1951
This is the outfield of the baseball diamond during one of the first games of the spring 1951 season. In addition to the finished field, the clubhouse can be seen in the background, with its recently added entrance to the left and the cupola on the roof.

CHAPTER TEN

Characters

All communities are known for the special citizens who add flavor to the local culture. Often mildly eccentric, these people are known for distinctive behavior, occasionally criticized but more often treasured and protected. Birdsey Parsons for example, after his wife died, became mildly reclusive. Wandering the streets of Sandy Hook with his donkey, Betty, he was a well-recognized local figure. Stories of his behavior became local folklore and are still told to newcomers, more than 30 years after his death.

One exceptional Newtown character was Jeff Briscoe, the grandson of a slave, he was mildly mentally challenged and was placed under the supervision of a conservator in the middle of the 19th century. He was able to master simple, repetitive tasks such as driving the local stagecoach to the train station to transport visitors to Newtown's resort hotels. He came to be beloved by those with whom he worked and especially those who he transported, to the extent that if he did not pick them up at the depot, they quickly asked if he was alright. His very expensive headstone is a visible sign of the high esteem in which he was held.

Men like Robert Fulton, on the other hand, were brilliant, and from that brilliance came their distinction. His interesting invention, the flying automobile or Airphibian, was well before its time. Fulton was never able to get sufficient funding to bring his invention into production. More than 50 years after the prototype, however, new interest has developed, and there is a move by his heirs to bring Futon's dream to reality. Another of his inventions, the Skyhook, did go into limited production and has been responsible for saving fliers' lives.

Still others are footnotes to Newtown's history. Carolyn Booth, for example, was part of the town's lowest class and as such would not have generated any documents. Her existence would thus have been invisible to history. She was shot, however, and *The Newtown Bee* provided a glimpse of her life, reporting on the circumstances of her wounding. Once the mystery of what happened was reported, she again disappeared into obscurity. Booth is a fleeting legendary local, but, with the rest of them, contributes to Newtown's distinctive personality.

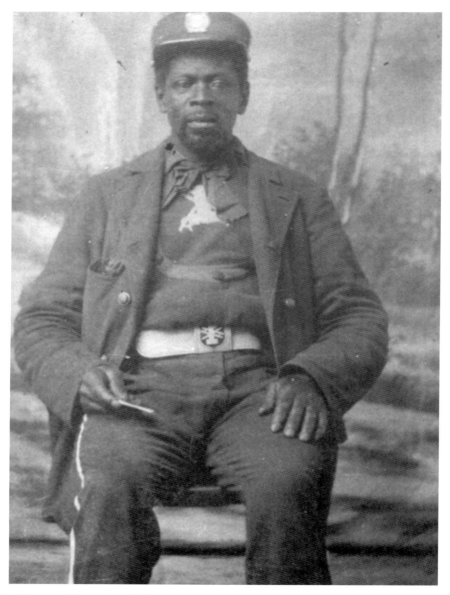

Alfred Jefferson Briscoe, c. 1890

This is the only known photograph of Alfred Briscoe, popularly known as "Jeff." He was the grandson of Alexander, the slave of Capt. Nathaniel Briscoe. Alfred was mildly mentally challenged, and in 1856, he was declared incompetent by his father. He could, however, handle simple tasks. With the help of a conservator, he held custodial jobs in several local factories before finding a vocation as a driver of local stagecoaches that transported guests between the Main Street hotels and the railroad depot on Church Hill Road. While so employed, he became immensely popular. Returning guests would ask for him by name if someone else picked them up at the station.

He was very proud of his membership and participation in the Newtown Hook and Ladder Company. Briscoe's pride is evident in this tintype photograph, for which he carefully decked himself out in his fire company uniform.

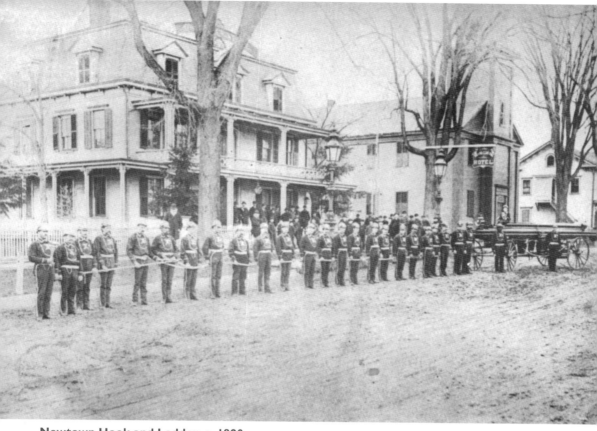

Newtown Hook and Ladder, c. 1890
The Newtown Hook and Ladder Company, founded in 1883, was the first firefighting company in town. Here, its members stand in a single line, holding the fire hose that extends from the hand-drawn hose and ladder truck, the company's first piece of firefighting apparatus. Jeff Briscoe, in full uniform, can be seen standing at the right end of the line.

Behind them stands the Grand Central Hotel (see page 82). Briscoe drove a stagecoach to transport guests between this hotel and the railroad depot on Church Hill Road. He had an apartment in one of the barns in the rear of this building, living there for the last eight years of his life.

Briscoe in Death, 1898

"Jeff" Briscoe died in 1898 and was buried in the southeast corner of the Village Cemetery. He was so popular that his was one of the few obituaries to appear on the front page of *The Newtown Bee*. Local residents circulated a subscription paper to raise money for a grave marker. The result is the elaborate metallic monument seen here. These monuments were very expensive, this one even more so. Above the commemorative plaque that bears his name is a representation of a fire helmet in raised relief. The helmet image is cast into the fabric of the monument body, meaning that the monument was cast specifically for Briscoe and was not just a stock model on which his name plaque was added.

$200 REWARD

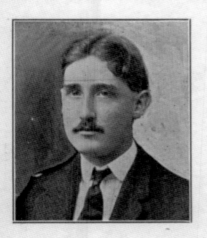

S. CURTIS HAWLEY.

FOR RETURN OF

S. CURTIS HAWLEY

who disappeared from his home in Sandy Hook, Conn., on June 11th, 1905.

DESCRIPTION:

Black Derby Hat, Dark Mixed Suit, White Shirt, Black Lace Shoes. Weighs 140 lbs. 5 feet, 9 inches tall; 24 years old; Light hair worn long and parted in the middle; light moustache, short; walks with eyes fixed on the ground.

Person finding Hawley, communicate at once with MRS. JULIA C. HAWLEY, SANDY HOOK, NEWTOWN, CONN.

Telephone, Newtown 9-5.

Wanted Postcard, 1905

The subject of this postcard, S. Curtis Hawley (1880–1943), was 24 years old and was born on modern Route 34, just across from the driveway to Curtis Packaging. He was described as "perpetually disturbed" and in need of constant care. On June 11, 1905, he visited his home while on leave from the institution in Bridgeport where he was living. On that day, while out walking toward the Housatonic River with a Mr. Connelly, Hawley came to a barbed-wire fence. He easily passed under it, but it took a little longer for Connelly to cross the same barrier. When Connelly reached the other side, he looked up to find Hawley gone.

A search party of 25 men was formed, but Hawley was not found. Meanwhile, the postcard shown here was printed and sent out, to no avail. A week and a half later, following claims of having been spotted in Stepney and Hawleyville, Hawley appeared, emaciated and barefoot, with his shoes in his hands, in the backyard of Charles Mead of Bethel. Having been spotted, Hawley took off, but Mead caught up to him and restrained him. A friend of Mead's suggested that the young man was the missing Hawley, and so he was brought back to his mother, Julia Hawley, the woman who issued the card. The two men split the reward.

Hawley was moved to the newly built Fairfield Hills Hospital in 1935, living quietly there until he died of pneumonia on February 6, 1943.

The Victim

HE HUT NEAR WHICH THE SHOOTING OCCURRED.

Carolyn Booth, 1897

Carolyn Booth had been shot. There was no question about that. But there was a question about who shot her. According to the initial story, Booth, about 60 years old, had been living with her paramour, James Tuttle, in a small, dilapidated shack on Botsford Hill Road, about two miles north of the railroad underpass. On Saturday morning, April 10, 1897, she was approached by two "tramps" who asked her for a dozen eggs. When they took five more eggs without paying for them, Booth chased them down the road. The men wheeled about and pulled out their pocket pistols, shot her in the face just under the left eye, and left her for dead.

The truth was a little more complicated. Booth had just had a violent argument with Tuttle when the tramps arrived. She followed the tramps, demanding her money, but Tuttle was standing a few feet behind her and, having pulled out his own pistol, began exchanging shots with the tramps. One of his shots hit Booth.

She survived, and her husband and daughter entreated her to return home with them, which she appears to have ignored. At this point, Booth and Tuttle drop from view and efforts to find out what happened to them have been to no avail. This drawing, which was done for the *Bridgeport Herald*, is the only known likeness of Booth and her crude shack.

In the greater scheme of things, this is not a very important case. It involved an impoverished couple living illicitly in a rude shelter in one of the outlying areas of town. These are the people that history generally ignores. It is only when a newsworthy incident occurs, such as the Booth shooting, that they briefly appear and give us a glimpse of their lives. It is interesting, however, to note how quickly they again disappeared after interest in the crime dissipated.

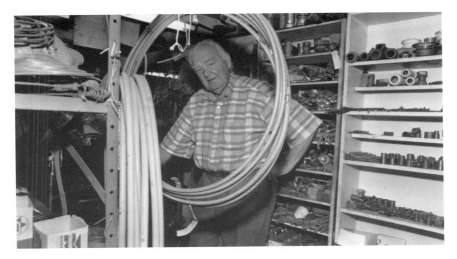

Al Penovi, 1997

A true friend to anyone who had a plumbing problem, Al Penovi (1916–2010) was as much a fixture on Sandy Hook's Washington Avenue as any of the plumbing fixtures scattered on the front lawn of his shop. The plumbing shop was a small hay barn that Al's father, also a licensed plumber, converted when he set up business in 1938. On his father's death in 1960, Al took over what had been their partnership. He was best known for his comprehensive inventory. Anyone looking for a part for an old, malfunctioning plumbing fixture could find it at Penovi's, along with information and advice on how to install the part, or how to solve any other knotty plumbing problem. His cluttered yard (below) was occasionally criticized as an eyesore, but more often was defended by appreciating neighbors. (Above, courtesy of *The Newtown Bee*; below, courtesy of David Rowe.)

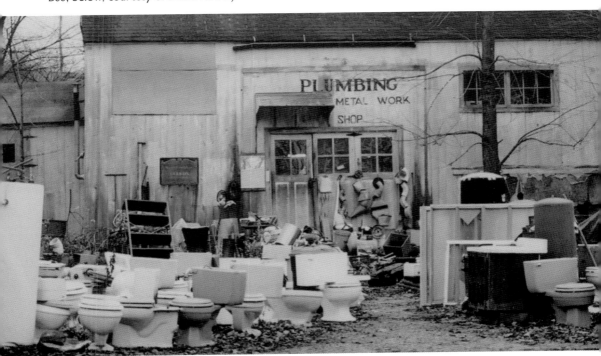

Robert E. Fulton Jr.

Fulton was Newtown's premier adventurer and inventor. His position as an adventurer was cemented by a trip that he made on a modified twin-cylinder Douglas motorcycle. Over the course of a year, Fulton motored from England, through Europe, across the Middle East, and across central Asia to Japan. From Tokyo, he took a boat to San Francisco and proceeded to cross the United States, arriving in New York in time for Christmas in 1933. His 1937 book *One Man Caravan* chronicled his trip. He also recorded his adventures on 40,000 feet of 35-millimeter film, which was released in 1983 as a 90-minute documentary, *The One Man Caravan of Robert E. Fulton, Jr., An Autofilmography.*

Of the 70 patents in his name, one of his most important inventions was the Skyhook, which enabled planes to rescue downed fliers or recover intelligence operatives from difficult places. This device was responsible for saving many fliers' lives during the Vietnam War, and it was featured in the James Bond film *Thunderball.*

The Airphibian (OPPOSITE PAGE)

Fulton's most intriguing invention was the Airphibian. Invented in 1945 and developed over the course of the 1950s, it was a small, two-seat automobile that resembled the front half of a light plane. To this could be attached a back section of fuselage with fabric wings and, in front, a three-blade propeller. In this configuration, the vehicle was an FAA-certified plane capable of maintaining speeds of 100 miles per hour. Without the wings, fuselage, and propeller, the vehicle was a ground car (see below) capable of traveling up to 60 miles per hour. Funding was a major problem, to which the invention finally succumbed after only four prototypes were built. One of these is displayed at the Smithsonian. Recently, there has been renewed interest in producing a flying car along the lines of the Airphibian.

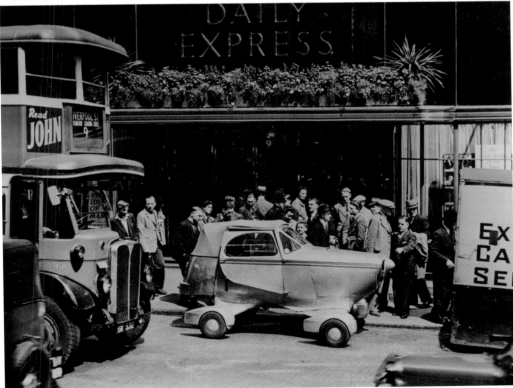

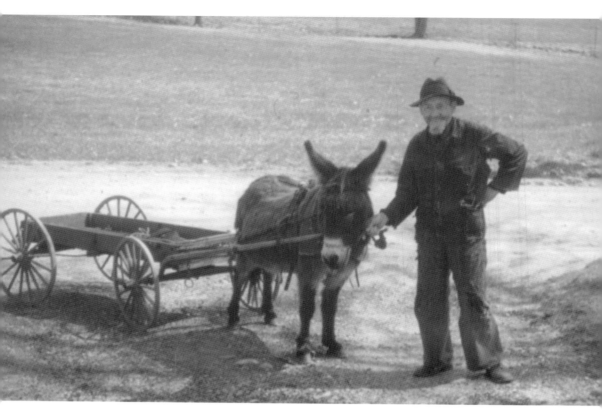

Birdsey Parsons and Betty, 1950
Birdsey Parsons (1884–1979) was a universally recognized citizen of Sandy Hook who, at midcentury, was known for his almost daily trips to Warner's Store with his donkey, Betty. When the donkey died, Parsons continued his travels on a Cub Cadet riding tractor. He had worked occasionally for the Plastic Molding Company in the Upper Factory on Glen Road during World War II. He would work only until his yearly wage was high enough to begin paying taxes, whereupon he would then quit. It appears that he hated to pay taxes. He had been married and had several children, but when his wife died in 1942, he became reclusive, living in a series of shacks he built on Washington Avenue where Route 84 runs today. When the highway was being built, the state moved Parsons to a plot on Jeremiah Road and rebuilt his shacks and woodpile. (Courtesy of *The Newtown Bee*.)

Parsons's Sheet Music, 1954
Parsons, it seems, wrote songs beginning at least by the late 1920s. According to several Sandy Hook residents, he would sell hard cider, or, more precisely, he would sell pieces of his sheet music, for which the purchaser was entitled to a healthy drink of cider. In this way, he was not selling hard cider, which would have been a violation of the law. (Donated to the Newtown Historical Society by Elayne Arne of Texas.)

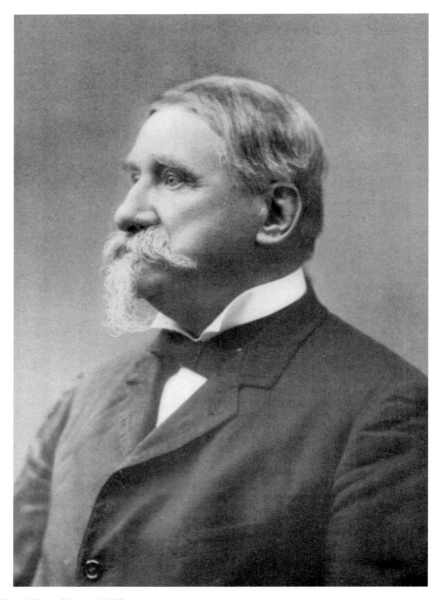

P. Lorillard Ronalds, c. 1900
Ronalds (1824–1905) resided in Newtown for a relatively short period of time, but his impact has lasted to the present day. He was born into a wealthy family, his mother being part of the Lorillard tobacco family. Ronalds generated his own fortune in the plumbing supply business. With that money, he indulged his love for horse-drawn vehicles. He was known as the "father of American coaching" and was recognized internationally for his ability to handle teams of horses under the most exacting circumstances.

It was reputed that Ronalds was on one of his coaching tours of Connecticut when he discovered the high promontory in Newtown that would become known as Castle Hill. This hill, just west of the village, had exceptional views of the village and all other points of the compass, including Long Island, visible on a clear day. On that spot, he decided to build an incredible mansion that was locally known as Castle Ronalds.

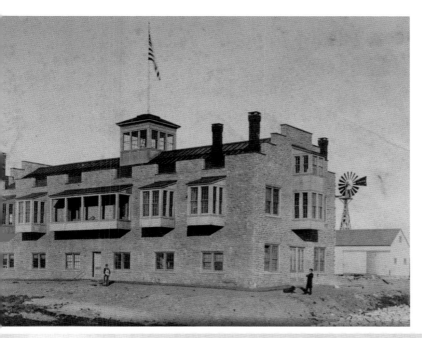

The First Castle, 1890

Begun in 1888, this building was of an eclectic architectural style heavily influenced by Ronalds's ancestral home in Scotland. It was built with an open north end (opposite the side seen here) so that he could drive his coaches into the building and disembark into the first floor. Eventually, there would be an east and west wing extending from the main section of the building, seen here.

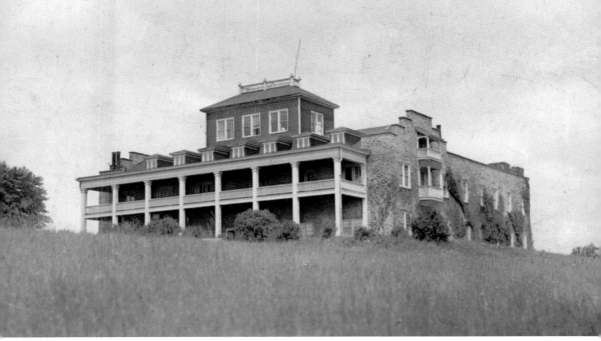

The Finished Castle, 1932

After a disastrous fire in 1890, the building required extensive rebuilding, resulting in the structure seen here. After Ronalds's death in 1905, the building was willed to his secretary, Elizabeth Blake, who originally tried to turn it into a sanitarium. This quickly failed, and the sheer size of the building and the expense to maintain it discouraged other uses. Having become a dangerous liability, it was torn down in 1947.

Men's Literary and Social Club, 1994
This photograph of the Men's Club was taken at Richard Gretsch's house on Castle Hill on the occasion of the club's 100th anniversary. This club is constitutionally limited to 20 members. At rotating meetings, one member buys dinner for all the others and another supplies the literary entertainment. The membership consists of the town's leaders, as can be seen from the number of members who are subjects in this book.

Shown here are, from left to right, the following: (first row) Merlin Fisk, John Madzule, Daniel Cruson (this book's author and the speaker on this night, later a member), Scott Connover, Jim Morley, and Al Nichols; (second row) Richard Sturdevant, Guy Van Syckle, William Meyer, Robert Grossman, Alfred Parrella, Joseph Engelberger, and James Osborne; (third row) Robert Hall, Richard Gretsch, Robert Schmidle, Donald Studley, William Lavery, Rus Strasburger, and William Hona.

Sandy Hook Memorial

On December 14, 2012, as this book was being written, a demented young man forced his way into Sandy Hook Elementary School and began shooting. Before he took his own life, 20 first-grade children, six faculty members, and a member of his family were dead. The tragedy reverberated around the world, and many, many memorials were set up. Numerous banners and messages were sent to the victims' families, to the school, and to the town in general. It is estimated that in the two months since the shooting, over half a million pieces of mail were received in Newtown, most of which were put on display in the Municipal Center, the Edmond Town Hall, and the Cyrenius H. Booth Library. The question of how to respectfully save all of this memorabilia will be debated over the next several months. Most of the organic material will probably be composted and the soil used in the foundation of a more permanent memorial, so that the physical presence of the earliest memorials and messages will remain.

The Sandy Hook School will remain closed for at least the remainder of the current school year. The students have been offered a place to study and continue learning by the neighboring town of Monroe in its recently mothballed Chalk Hill School. The fate of the Sandy Hook School building is also the subject of many conversations in town. There is a strong feeling that it can never be reopened as a school.

Among those most affected by the tragedy were the police, ambulance, and fire first responders on the scene. Virtually all of these people are back at their jobs, but not without the scar tissue of having been at the tragic scene. The town also extends its profound thanks to the army of other first responders who came to help from all over the state of Connecticut.

The collection of 26 angels in this photograph was located on Church Hill Road, overlooking the site of the school. This image has been selected to remind the reader of 26 legendary locals whose lives were cut short. (Courtesy of Shannon Hicks and *The Newtown Bee*.)

IN MEMORIAM

Charlotte Bacon

Daniel Barden

Olivia Engel

Josephine Gay

Ana M. Marquez-Greene

Dylan Hockley

Madeleine F. Hsu

Catherine Hubbard

Chase Kowalski

Jesse Lewis

James Mattioli

Grace McDonnell

Emilie Parker

Jack Pinto

Noah Pozner

Caroline Prevdi

Jessica Rekos

Avielle Richman

Benjamin Wheeler

Allison N. Wyatt

Rachel Davino

Dawn Hochsprung

Ann Marie Murphy

Lauren Rousseau

Mary Sherlock

Victoria Soto

BIBLIOGRAPHY

Cruson, Daniel. *Mary Elizabeth Hawley*. Newtown, CT: The Newtown Historical Society, ND.

———. *Newtown*. Charlestown, SC: Arcadia Publishing, 1997.

———. *Newtown, 1900-1960*. Charlestown, SC: Arcadia Publishing, 2002.

———. *Judge William Edmond*. Newtown, CT: The Newtown Historical Society, ND.

———. *Educating Newtown's Children: A History of Its Schools*. Newtown, CT: The Newtown Historical Society, 2000.

———. *A Mosaic of Newtown History*. Newtown, CT: The Newtown Tercentennial Commission for the Newtown Historical Society, 2005.

———. *The Slaves of Central Fairfield County: The Journey From Slave to Freeman in Nineteenth-Century Connecticut*. Charleston, SC: The History Press, 2007.

Johnson, Ezra. *Newtown's History and Historian*. Newtown, CT: Privately published, 1917.

Mitchell, Mary and Albert Goodrich. *Newtown Trails Book,* fifth ed. Newtown, CT: The Friends of the C.H. Booth Library, 2000.

———. *Touring Newtown's Past: The Settlement and Architecture of an Old Connecticut Town*, Newtown, CT: The Newtown Historical Society, 1996.

Smith, Mortimer, *One Hundred Years of Schools in Newtown*. Newtown, CT: Bee Publishing Company, 1946.

Zimmermann, Andrea, *Eleanor Mayer's History of Cherry Grove Farm: Three Generations on a Connecticut Farm*. Newtown, CT: The Newtown Historical Society, 2005.

Zimmermann, Andrea, Daniel Cruson, and Mary Maki. *Newtown Remembered: Oral Histories of the 20th Century*. Newtown, CT. Bound and available at the C.H. Booth Library, 2002.

Zimmermann, Andrea, Mary Maki, and Daniel Cruson. *Newtown Remembered: More Stories of the 20th Century*. Newtown, CT. Bound and available at the C.H. Booth Library, 2005.

———. *Newtown Remembered: Continuing Stories of the 20th Century*. Newtown, CT. Bound and available the C.H. Booth Library, 2010.

INDEX